D1336722

Shelf life

NEIL GALL

black dog
publishing

contents//

simon groom//

/DIALOGUE

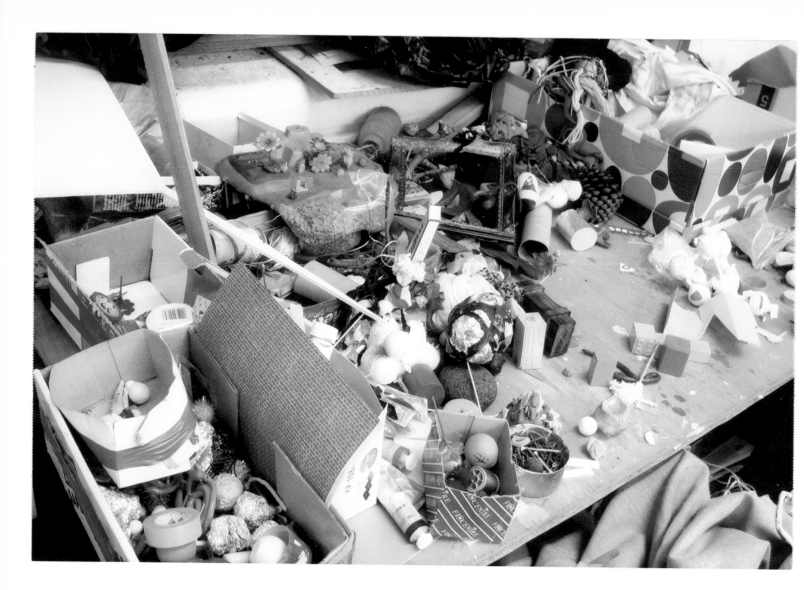

[Simon Groom] Always a good place to start is with the studio and it's very interesting coming into yours and looking around, especially as a lot of your work is what you call "mimetic", it mirrors the world around it from which it derives. Looking at your studio the thing I'm most struck by is the sense of neatness and order: the books are all arranged, the CDs are all stacked up, you've got shelves of models, your brushes are arranged by size and they're clean, they're all clean, which is extraordinary. But over on the desk and work surfaces it's an absolute mess, it's chaotic. I was wondering whether you find that the state, or rather states, of your studio actually mirrors your approach to life, or your approach to the work?

[Neil Gall] A good observation. The division between the paintings and the objects are very much evident in the organisation and dis-organisation in both those worlds. To make paintings like these one has to be quite organised, quite disciplined, whereas the state of mind I find I need to be in to make the objects is quite different.

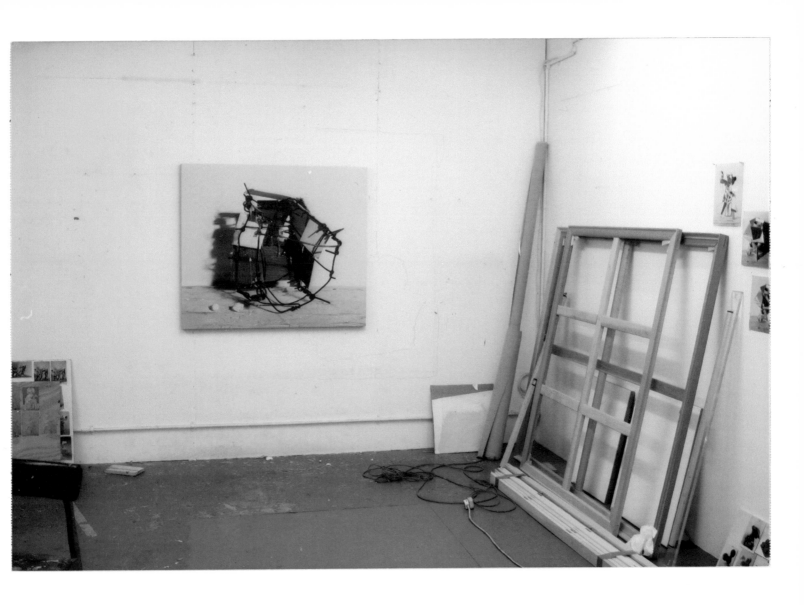

It's worth just picking up very early on the fact that you're a painter that actually makes objects, and a lot of your paintings are based on objects. Could you take me back to your first use of an object as a basis for your painting?

> The first significant object was a wire basket rescued from the skip outside the studio. A utilitarian, domestic object; I think it was either a dish rack for draining plates, or perhaps a basket that is attached to the front or back of a bicycle. It was a cocked up sort of thing, twisted and fouled, dirty. I guess I was attracted to it through its resemblance to an abstract grid.

I like the fact you're attracted to something that has a practical utility you're ignorant of, but nonetheless has a completely different use for you.

> Of course, I was going to make this not very useful object called a painting at the end of it! But I guess it was free enough from connotations for me to use this found object as a formal device.

And you approached it in art historical terms: formal structures, the idea of the grid but a fucked up type of grid, which perhaps could serve as a way through. I'm interested in how absolutely central the grid has been and perhaps still is.

> I did get interested in that area, *Painting as Model*, Yve-Alain Bois for example, a lot of that sort of theory; it did however get to be such a burden. So my fucked-up grid was a perfect way out; a way out of all those MIT books, abstraction and its complicated history. I needed a way out.

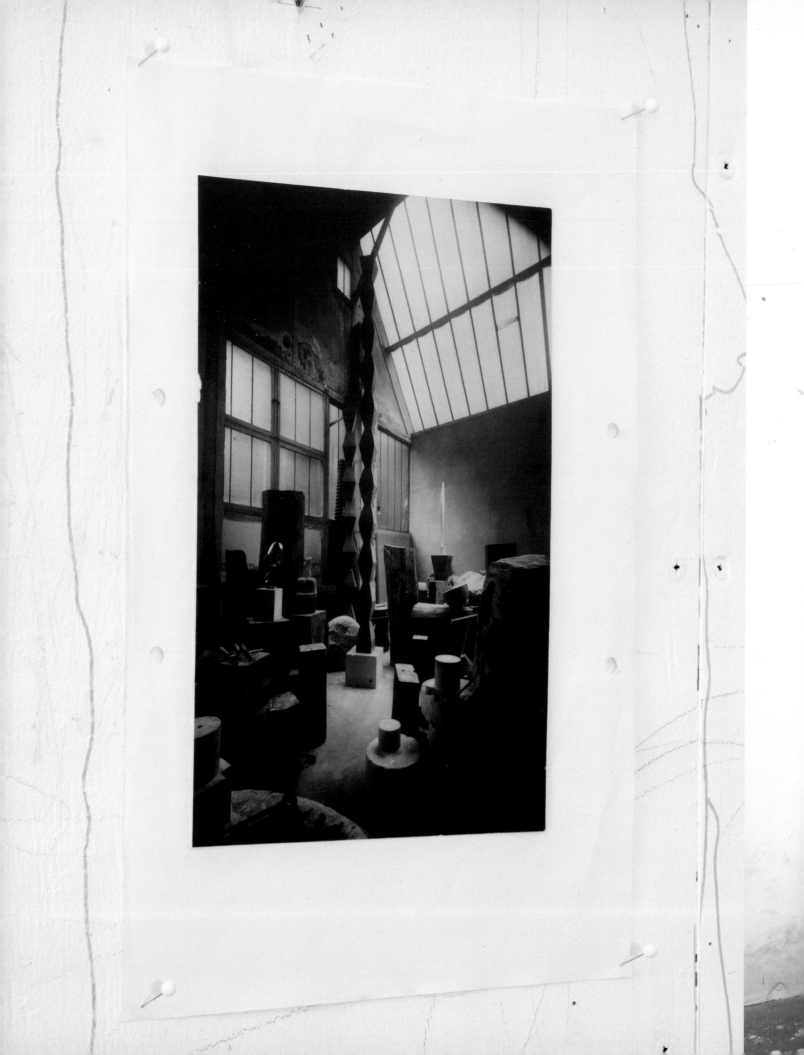

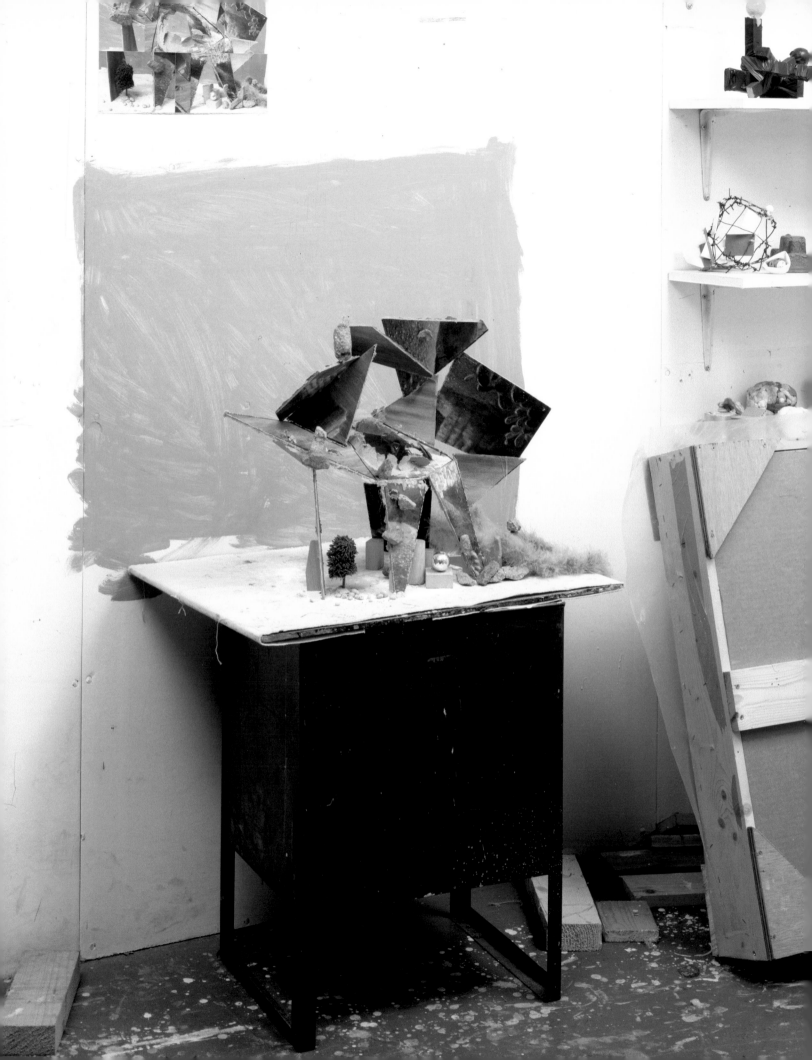

Already we've picked up on that. It's not a schizophrenia but it's a kind of doubling, both in the order and the chaos of the studio, and now you've brought up another one, the theory and the practice, or perhaps the idea of something and its actuality. If you can go back to that idea of the first object that you found from the skip, what did you do with it?

> When it becomes an object in space, if you have a backdrop, if you put it next to the wall, it defines a literal space almost like a set of co-ordinates. It defined a shallow space that I could then transfer to a flat canvas. I suppose partly it was about finding some space in the painting, and of course the grid is a flat-tening device; but this real-space grid put a little bit of literal depth into my painting.

So this model allowed you to develop space in a way you hadn't been able to before. Could you just describe the kind of painting you were making before this discovery?

> Most of the work I made at the Slade, and the six to seven years beyond, was much flatter and concerned with the grid in a more classic sense — making abstract paintings. I was very influenced by my tutor there, Ian McKeever; it was new to me at the time, that you could occupy, like him, two seemingly irreconcilable positions — on the one hand having a lyrical and emotional approach to abstract painting whilst on the other a strong conceptual basis. Richter was also a big influence.

OK. And I think the important thing, rather than just admire this structure in space you actually do use it as the model to paint from. Could you explain in what way you painted? Whether you were trying to make a literal transcription of it, or use it as a device to discover that space?

> Very much the latter. I didn't want to make a traditional still-life painting; coming from my abstract painting background that was never an option. What kind of painting did I *want* to make from the model?

Cast
2003, metal plinth, wood
and various found objects,
92 x 46 x 31 cm

What kind of painting *did* you make?

> Well the paintings I made did look like abstract paintings even though they
> were figurative; their abstract nature was generated by the indeterminacy
> of the wire model itself combined with the limitations of the technique — the
> un-modelled, thickly applied paint.

What did they remind you of?

> I suppose as a picture they looked a bit like a kitchen-sink version of say
> Brice Marden.

Very domestic.

> Very un-heroic.

**However, even though it was domestic and un-heroic, it suddenly opened up a
whole new space that wasn't there hitherto. Were you pleased with the results?
Was it actually a painting where you thought, "Yes that's a eureka moment?"**

> Yes, it was liberating because you have something that refers out-with the
> conceptual, intellectual basis of making abstract painting. You are working
> with something that is real, and there are objects in the world beyond this
> basket! Having said that, I then painted it about 25 times over the next three
> years; literally the world had opened up to me and therefore the possibility of
> other pictures, which is your primary need as a painter, not just the picture
> you are working on. You want to believe that you are involved in some kind of
> territory which has potential.

**So you have got quite a formalist device, in a way, at the beginning, to something
that allows your painting to move into new territory. You've said that you began to
add more objects to this — this presumably is where the scrunchy comes in.**

> Yes, a very different object. The painting it appears in, *Cast*, has it placed
> pretty much centrally in a composition of objects all hanging off the wire basket.
> It becomes much more like a figurative painting, much more representational;
> you're pretty aware what this red object is. Suddenly, I'm in a very different area
> of content.

14

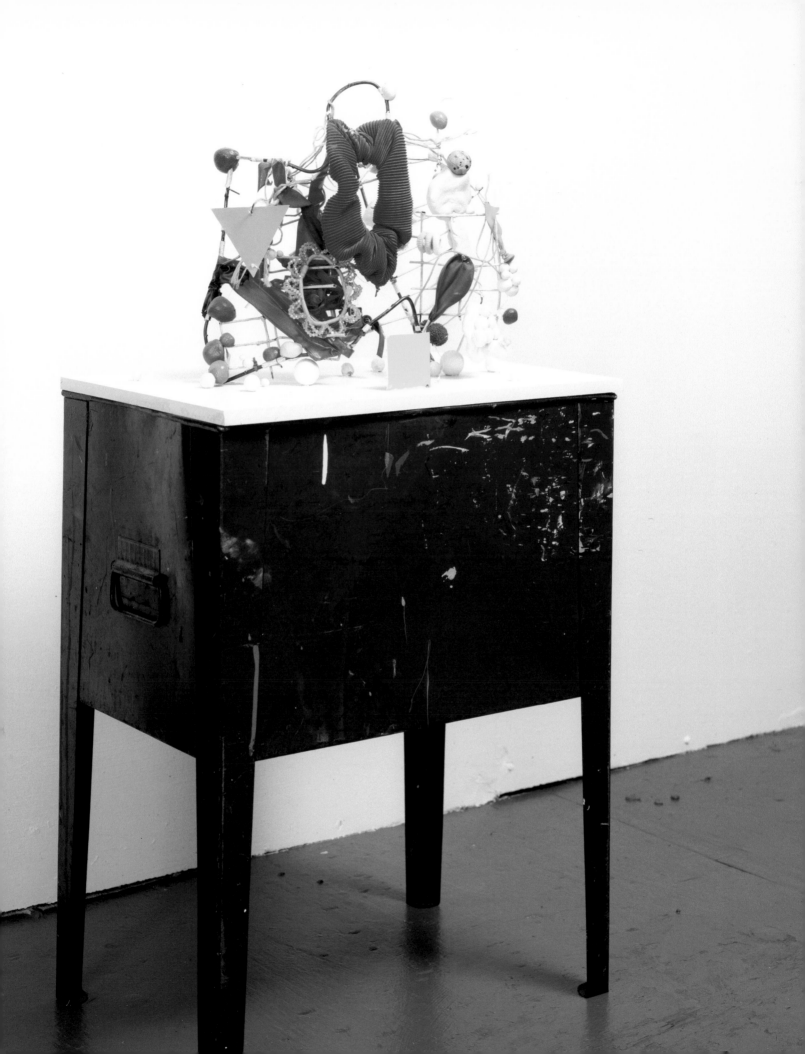

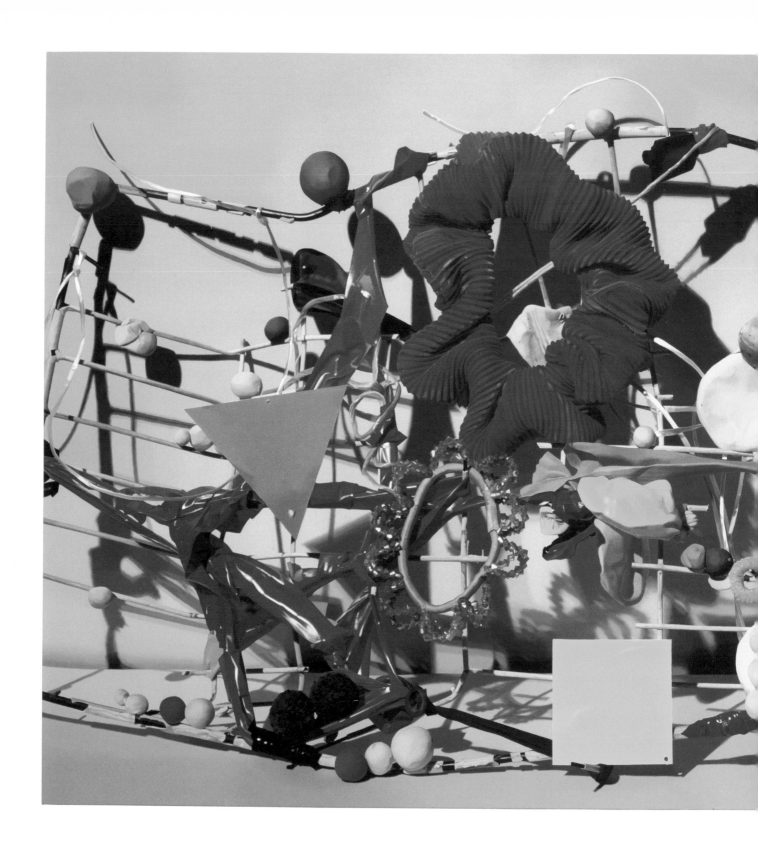

Cast
2003, oil on canvas, 223.5 x 305 cm

By putting in something that both described an area of colour but also related very directly to something incredibly identifiable to do with the real world, meant that the real world invaded the formal world and began to pull you in a different direction.

Putting the scrunchy on the basket and then making *Cast* over five months — a ten foot painting — there was a eureka moment of using the scrunchy and to the possibilities it opened up for my whole practice. And then during the painting of the picture seeing a show at the Whitechapel of New British Sculpture, Early One Morning, featuring people like Jim Lambie, Gary Webb, Eva Rothschild. Suddenly, there was a peer group, although all non-painters, some of whom were using similar objects to me in their work. It was a feeling of "Wow! I'm doing something that other people are doing!"

Making the previous work, even though there was a lot of abstract painting happening among young artists in London during the 90s — artists like Jason Martin, Ian Davenport — I felt pretty alienated from that group. I mean, not showing in a high profile way and also not painting through an explicit process. Of course, part of being an artist is to try to do something that no-one else is doing; to be original. But never having had this sort of kinship feeling — which I think most artists tend to get at some point, doing similar things, shared concerns — I'd never had that experience. I guess I'd always related to older artists. Anyway, the commonality made me feel I was on to something.

To go back to the scale, five months is quite a long time, and ten feet is a large painting, especially of a scrunchy. Why the great shift in scale, what were you trying to do with the size of it?

> I didn't really want to make a painting about a scrunchy of course; I think with the scrunchy being in reality three to four inches and the painting being so large, it increased the oddness of the scrunchy. So the scrunchy in *Cast* becomes about three and a half feet in height, which is sort of odd; I mean this pulled in other stuff — it becomes quite surreal.

With those paintings there is a real sense of stillness and suspension of time, of its being completely outside of any familiar comprehension. You recognise the ordinary elements but you just don't understand what these objects are doing together. It's a sense of having a metaphysical stillness almost, which of course relates both to a mental area and also to the real world; and I was just wondering, for you, what brings these things together? Because increasingly in your paintings you seem to be involved with formal structures which then lead off into narrative areas. What is it that brings these things together, these objects together as your models?

> Over the last four years I've collected and developed an array of characters which I keep: they are players in my evolving narrative and can come into use in different arrangements — endlessly it seems. Somehow they become protagonists with a fully formed sense of being, I can't predict why some are significant, with potential, and some are not. It can take a while for me to realise an object could be a protagonist rather than simply a structural element. Having established itself as a character, it then takes on a life of its own, participating in a variety of narratives. And why I decide to put one object with another — I can't explain. When I start to see a reason why things go together it becomes problematic. Things are constantly being chopped up to stop me second guessing.

It's intriguing, it's like you're trying to explore something unknown.

> Some of the objects are purely found objects, some are made — quite crudely, never taking a long time to make.

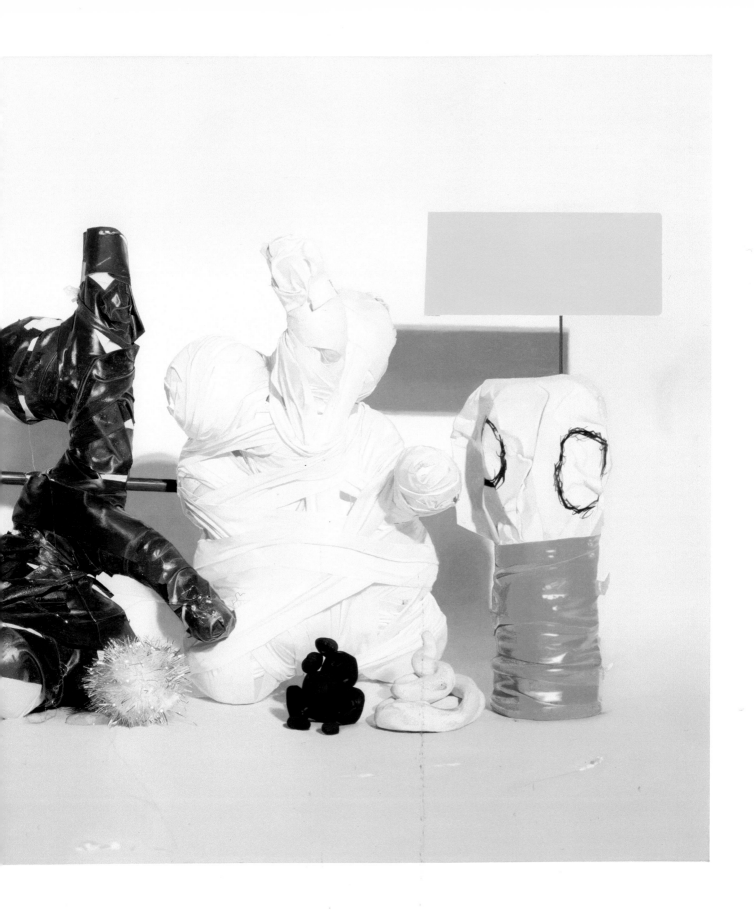

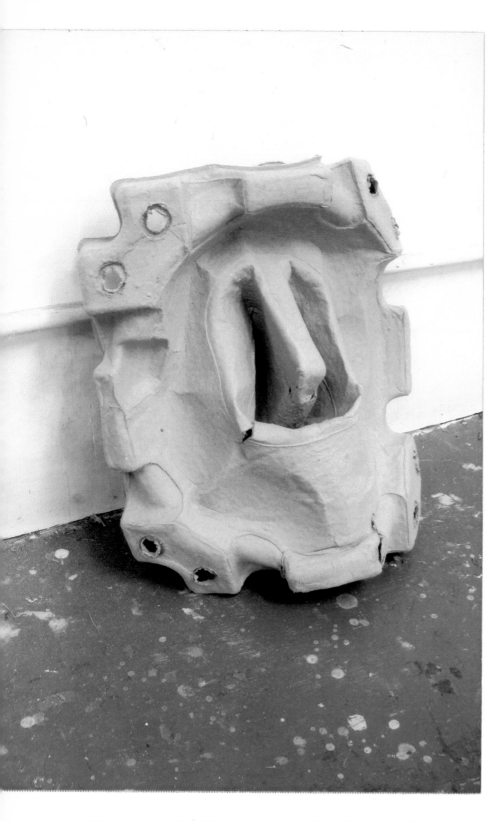

LEFT
Found object,
photographed in studio

OPPOSITE
Savonarola
2006, oil on linen, 102 x 81.5 cm

Describe some of the things that you make these objects from. What found objects have you used?

Looking at this object here, which resembles a kind of Easter Island head, it's a found object — an egg-box like material. Again, what the object originally was for, what was placed in it, I don't know. This is an example of a pure, unaltered object — apart from a wee twist which makes it become a head. However, most of the other objects are constructed in some sort of way, like the wrapped tape balls which use ping-pong balls and electrical tape in various colours, or this purple and white card and wire object which transforms into some kind of structure or habitation in the painting.

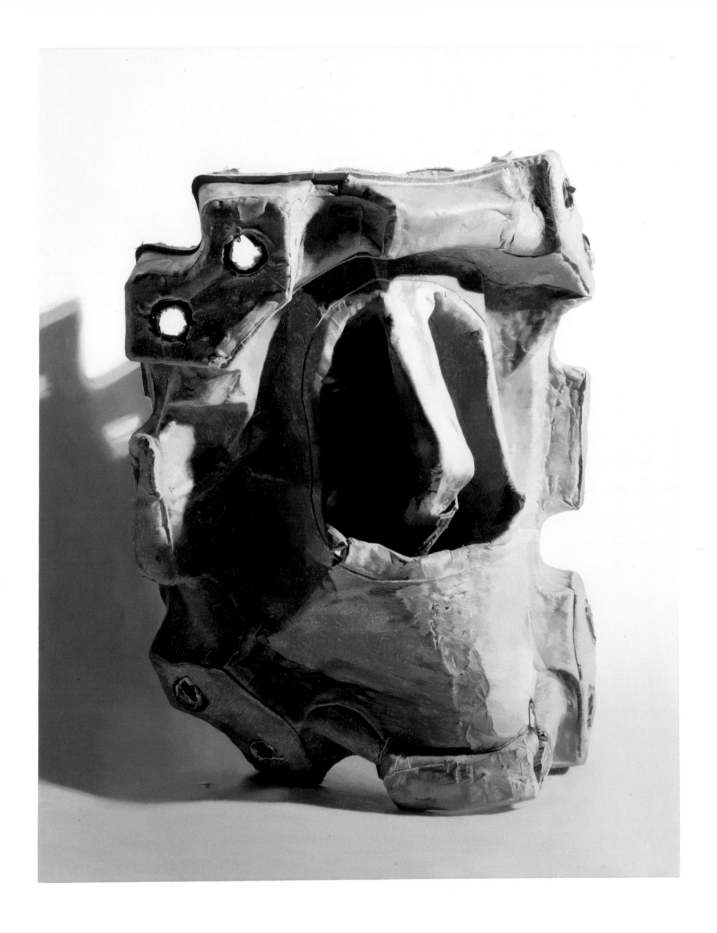

Between dusk and dawn
2007, oil on linen, 105 x 122 cm

I think the un-knowingness, the process in which these objects come into being, is an important part of my practice. I often find it difficult to assemble them in the studio actually. Sometimes I make them at home at the kitchen table — kids running around with normal domestic stuff happening — where perhaps I'm less self-conscious. My six year old son might sit next to me imitating the object I'm trying to fashion. The object being made in the everyday rather than the rarefied atmosphere of the studio somehow releases the unconscious, it frees me up, gives me the ability to make something non-sensical. I mean if I go to the studio on a Monday morning, I drop Louis off at school then go to my workplace — it never works to get out my plasticine; it's not a reasonable thing for a grown-up to be doing!

Making the objects at home gives you a reassurance, a justification and an excuse?

It seems like a normal thing to do at home, whereas in the studio it seems less acceptable: painting, though, seems more grown up.

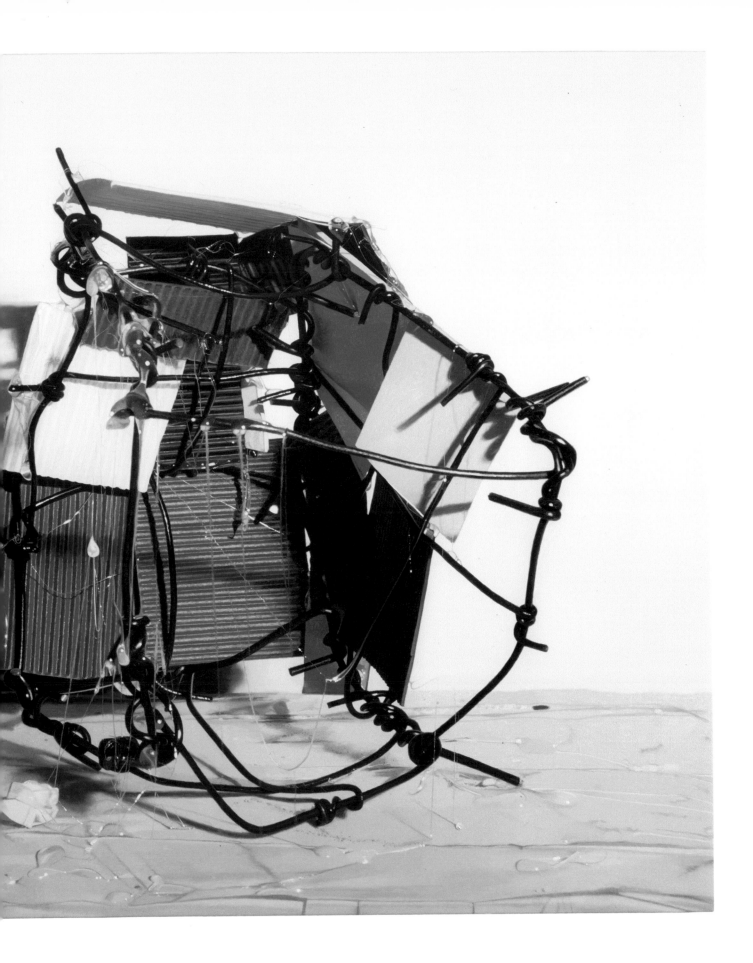

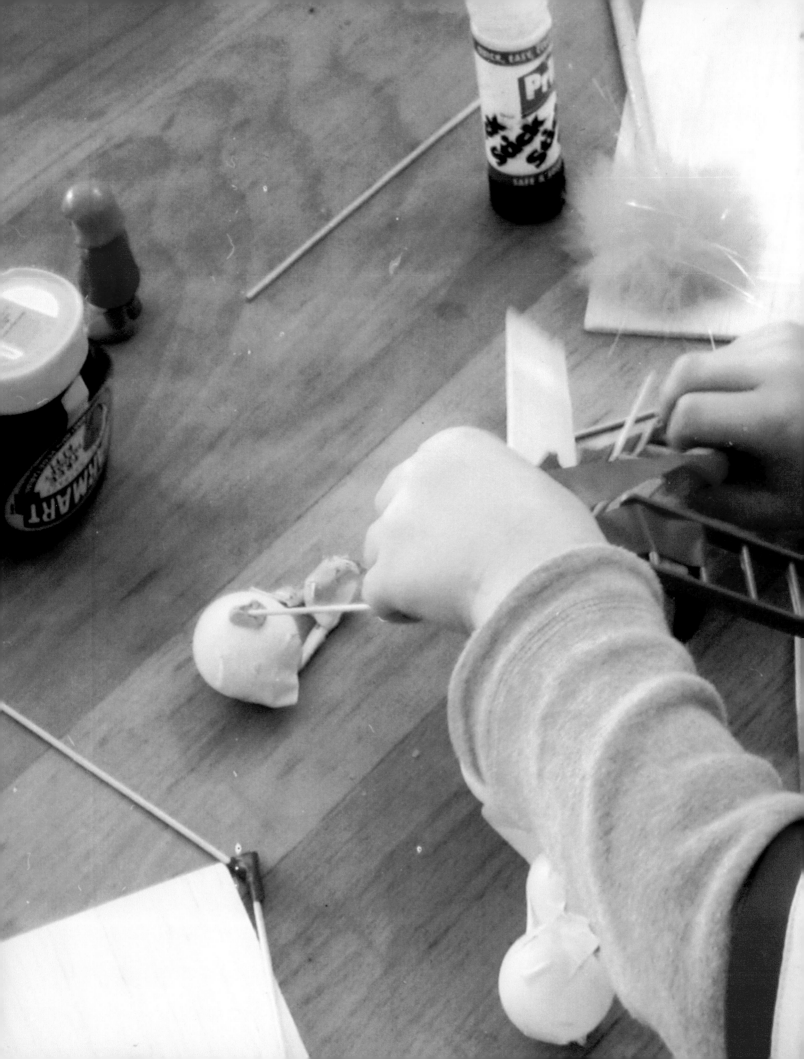

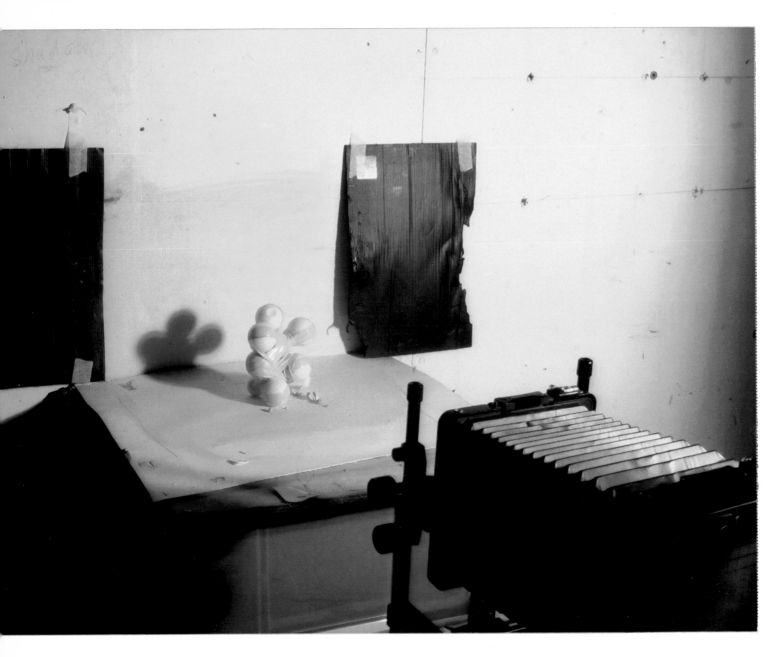

Ball figure being photographed

Going back to the object. I'm wondering whether these objects become more autonomous in their own right. When you look through the transparencies you're never quite sure whether what you're looking at is the object itself as a model, the object potentially as a sculpture, or the object itself as a painting because of the absolutely realistic depiction of the object transcribed to a 2-D surface. What is the status of the object?

> I think more and more I am able to see objects as sculptures in their own right. Also I'm able to see the photographs as images in their own right, which are the intermediate stage in the process. In the studio the divisions are quite clear, but the relationships are blurred on transparency or in a book.

Is that something you enjoy, blurring that distinction?

> Yes, anything that complicates my practice and confuses me is welcome.

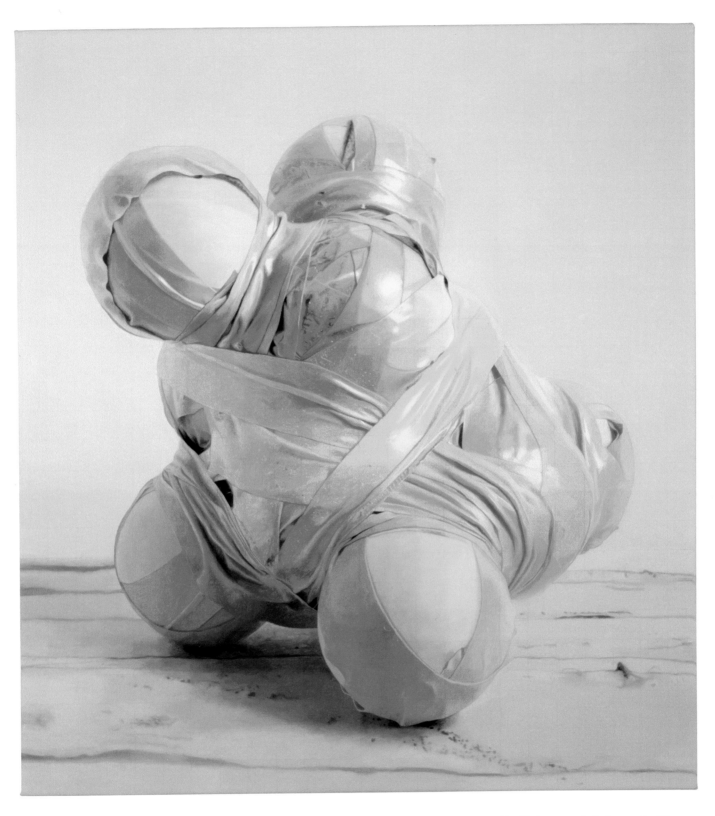

Unable to separate their own identities
2004, oil on linen, 66 x 56 cm

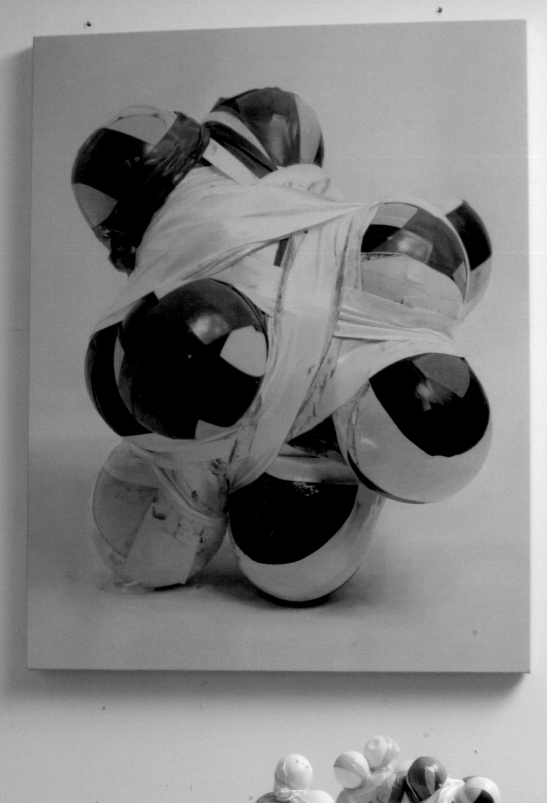

So one never quite knows whether one has finished a sculpture. Is that the
distinction between a sculpture and a model? The model, it has a fixed point
and you think "actually I'm going to stop there, because now I'm going to paint it",
whereas a sculpture actually assumes a life of its own and escapes that end point.

Yes, this more recent revelation of making sculptures rather than models for
pictures is exciting but I think that, perversely, these sculptures could become
models for paintings! To make a sculpture for its own sake and then use it as
a basis for a painting — that's the kind of self-deception I've found myself
having to come up with!

You always photograph the model and work from the photograph to make
the painting?

Yes. The work is always mediated through the photograph; doing it otherwise
leads you into, I suppose, a position of trying to grapple with slippages and the
discrepancies of transferring something 3-D onto a 2-D surface, which is
interesting but not for me.

What does most interest you?

I suppose I am animating these objects. On the shelf they are dead; by painting
them they are brought to life. I've used cast shadows a lot — we talked of
stillness, and you could say by implication that area of metaphysical art
occupied by artists like De Chirico. When they leave the shelf, and you have
a background, and you cast a shadow, there is life.

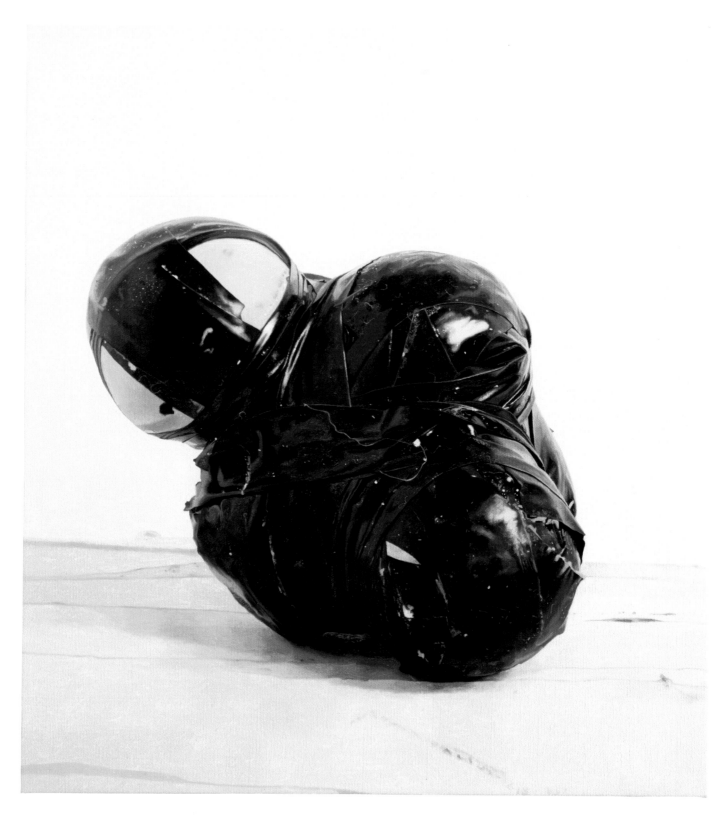

Performance
2004, oil on linen, 61 x 51 cm

I'm just looking at your painting of ping-pong balls wrapped in tape (*Performance*). There is an amazing discrepancy between the model and the painting; there's a model on the floor which is actually very grotty and just tacky looking, and when it's painted it suddenly becomes incredibly uncanny. It reminds me of all kinds of the dark surrealist thoughts of Hans Bellmer for instance, of bodies that are distorted, bound, gagged. There's something very human and alive and deathly about it. Is that the shift that you are talking about, in a way that when you paint it, it gives it life? And that idea, the figurative reference to a body, how central is that for you?

It's been a slow realisation actually. One particular painting, *Performance* — the earlier large picture, there was a turning point when I started to read some of the objects as being characters, actors, in a theatrical tableaux. There were three: one was like an owl or ghost with two eyes, one some sort of mashed-up head, and the other a wrapped-up ball form which became a strange performer on a plinth. Three protagonists seemed significant, it made me think more figuratively... for example, there are Picasso paintings with three figures, and they helped me to anthropomorphise the objects. And back to the grid, seeing these wrapped-up balls and how the tape goes around them in a criss-cross fashion, I feel that I've made this figure and by wrapping them up I'm gridding them up at the same time.

Maybe it's a metaphor for you as the artist inside struggling to get out of those things, or to get out of this habit!

There is a compulsive thing going on, this wrapping, it's how I understand these objects. When the ping-pong balls are on their own in space it's almost like I can't see them until they're wrapped, and of course the painting that is developed from the photograph has a pen grid drawn on it. The figures are imprisoned.

The idea of entrapment is quite interesting in your more narrative paintings.

The fantasy landscape paintings.

Yes. There is a sense of isolation and again that feeling of entrapment. Having made use of children's toys, very innocent objects; you've created something actually very disturbing. They give you a vision which welcomes you in, because they are absolutely delightful on the eye, although delightful's probably the wrong word. But you use glittery things, you draw people in, they are enticed, but as soon as you get in you realise how dark it is.

In *The Upperworld*, I think you start to wonder what these ball creatures are, when they are placed against things that you can readily identify, toy trees, a horse, you know what these things are, kids' things, innocent things, then you have these ominous ball forms in the landscape, slightly creepy. However I'm putting all these things together, playing formal games; I don't set out to make it creepy, all these things I've gathered about myself co-exist in the studio, the innocent and not so innocent. It seems perfectly natural to me that they can go together.

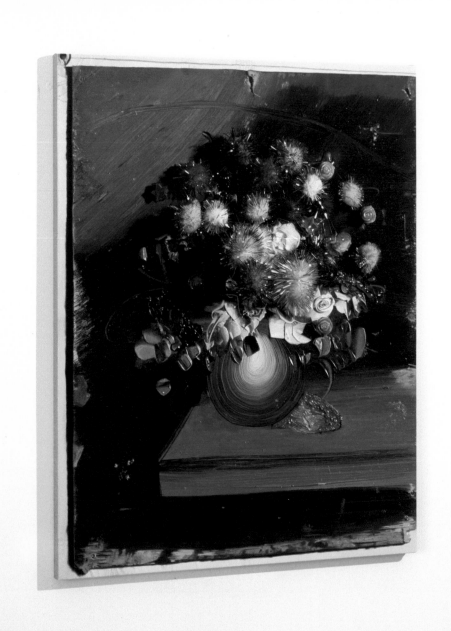

**Maybe it's precisely their normalcy that gives them their creepiness, because
it is that very uncanny feeling that something isn't quite right. Looking at your
more recent work, you've moved into collage. In a way, it relates to your idea of
outpacing your comprehension of the world around you because, again, you are
not just accepting the thing as it is, you are actually physically distorting it,
chopping it up, re-arranging it. But also the idea, the model, comes in much
more than it did before, as a formal element.**

First we should talk about the flower painting, *Greetings from Well Street*,
which is a collage painting in a way. I have used a junk shop painting as the
model; I've added some glittery balls which then become, or function as, flowers
in amongst the painted flowers. There is a big blue swirl in the middle of the
painting, the vase, which looks like a Howard Hodgkin brushstroke, and there
is this bravura brown stroke which designates the edge of the table on which
the blue vase sits. All these brushmarks are the work of the original painter
which I have faithfully reproduced in my painting.

The glitter balls are quite kitsch.

Sometimes the work does appear to veer towards the kitsch — I suppose
here we have again this combination of the kitsch, or the overly pretty, and
the creepy or sinister.

**Kitsch implies a sense of irony now because we are so aware of it yet I don't
see that sense of irony in a lot of your work, it's much more straight than that,
and though the objects may be pure kitsch, your paintings certainly aren't.**

The pictures are not kitsch like Koons, whose work is a celebration of kitsch
consumerism. Some of my objects are kitschy, but the paintings themselves I
don't think ever become kitsch, they are generally too abject for that. But I want
to return more specifically to *Greetings from Well Street*. It is a conceptually
and physically more complicated way of arriving at the photograph that then
becomes the painting. A painting of a collage or a found painting is, however, a
painting of something flat; although to be precise, the model for this picture is a
shallow relief; there is an inch of real space made by the attached glitter balls
and also the thickness of the original painting. I've painted its cast shadow on
the left hand side of the painting. So, in a way, I've come full circle, back to
painting flat. The collages are quasi-Cubist warped spaces; I'm essentially doing
a painting or drawing of a flat object even though the object in the collage is an
object in space. I think we've identified an obsession or hang-up about space in
my work: but perhaps this is not so important; a great painting can be as flat as
a Robert Ryman.

33

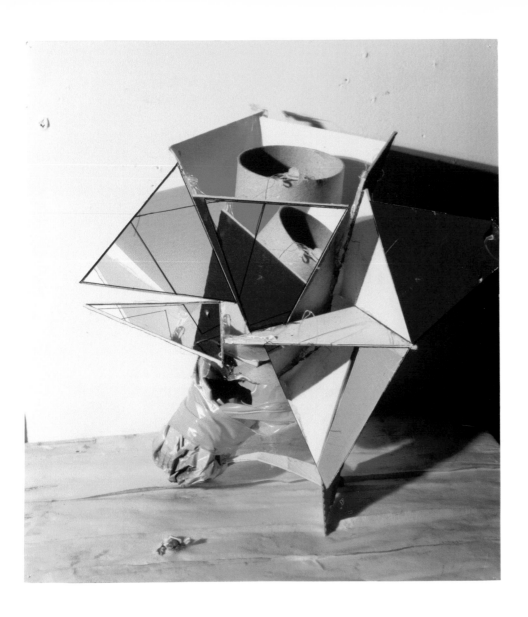

Are they made of card, these models? They recall, as you say, early Cubist sculptures, which are all to do with re-defining space. And now you're saying space is no longer so important. That again seems perverse. I'm just wondering if they're not looking for space. What is it about making these Cubist-looking models?

> Well, it's not about re-doing Cubism. These are recent explorations, I'm not sure yet where they're heading, although using Cubism to explore flatness does seem perverse!

To me it goes back to the idea of outpacing your sense of understanding, and it's about painting at those boundaries. If you're painting from photographs, why not start manipulating the photograph, which a collage does, and then you can paint the result? So in a way — and you're interested in models which become sculptures — painting is almost there only as an excuse now for your experiments in the previous stages of the process. Is that fair?

> At the beginning of the interview you described me as a painter; I suppose all this shuffling around, the layers of the process, gives me an excuse to make the painting. So I would say, it's the other way round.

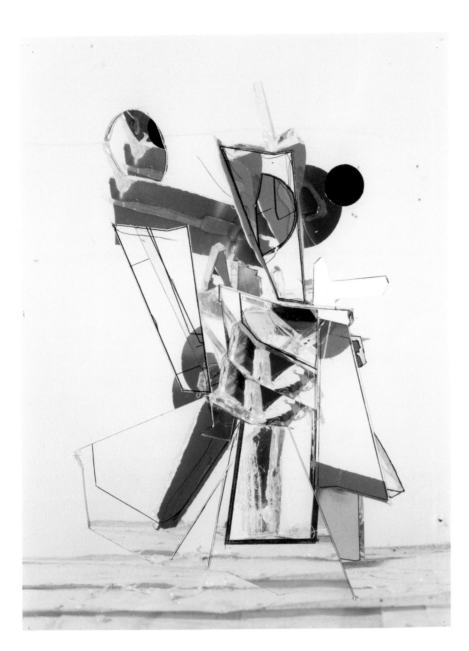

OPPOSITE
La Femme
2006, photo collage and pen, 24.8 x 22.7 cm

Standing figure
2006, photo collage and pen, 29 x 22 cm

Can you imagine having a sculpture show?

Maybe.

What would you lose in doing that?

My sense of myself as being a painter. I'm still nervous about the idea — I have shown the objects before with the paintings and once without the paintings, which was quite liberating in a way; realising no one blinks an eye. Why not? You're bound to your own conventions which you're always trying to escape, so everything must be possible. Painting for me is a daily compulsion and has been for many years. But with one's conventions come one's own inhibitions; if I'm willing to paint a straightforward painting of a found object proclaiming that it's interesting enough to have its portrait painted, can't it just exist as a sculpture? Yes, of course it can.

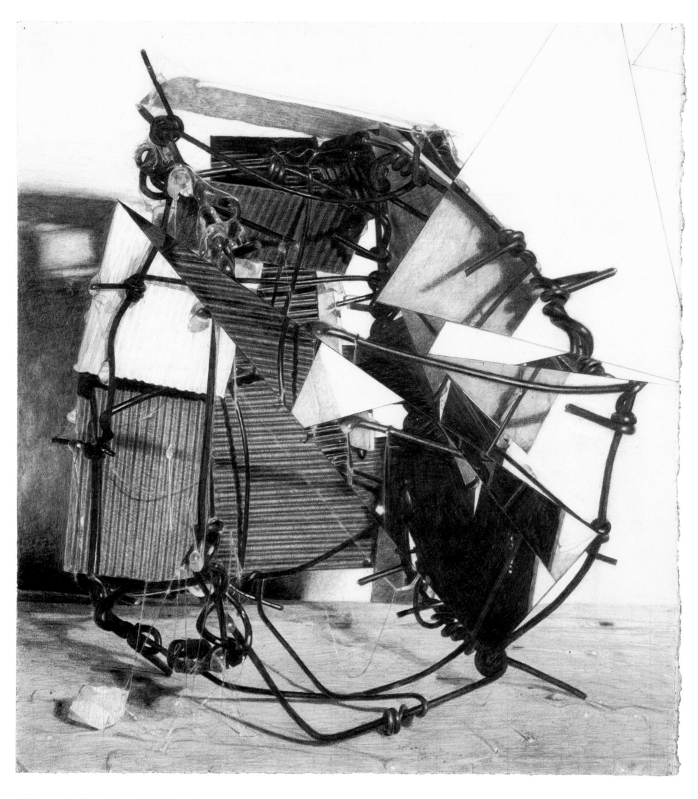

Between dusk and dawn, 1st attempt
2007, graphite on paper, 40.9 x 37.7 cm

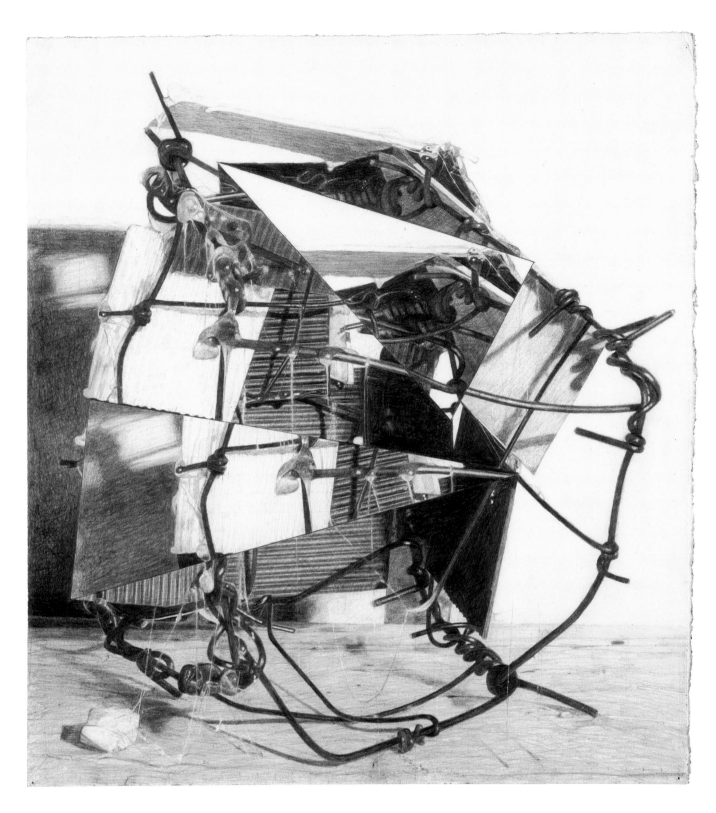

Between dusk and dawn, 2nd attempt
2007, graphite on paper, 40.9 x 37.7 cm

But everything you've been saying, which is about the transformative effect
either of your view of something — it goes back to the wire basket you found in
the skip — or the idea of something being literally itself: you have the sculpture,
you photograph it, again this becomes different without changing it, and then
you paint it. They are exactly the same model, the same object, but it becomes
something completely different in the three stages — the painting, the photograph
and the model. So now to say you'd be quite happy to just present the model by
itself; I think you're taking an amazing step because we were also talking before
about the fact that the sculpture down there, the balls wrapped together with
tape, is actually a grotty-looking thing that is transformed and full of vitality
when it is painted.

> I know there's a big contradiction in all that. To pick up on the contrast in the
> grottiness of the object and the beauty in the painting, I remember someone
> saying to me that you would assume that the paintings were made in some
> kind of penthouse studio — like Jeff Koons, for instance — but it's not like that.
> The studio is in the east end of London, a largely run down part of town, and I
> take these soiled objects from the skip and try to elevate them, to paint their
> portraits. This new acceptance by me of the object or model as untransformed
> sculpture is, I suppose, seeing the beauty in the abject; it was always there,
> that's why I painted the thing in the first place.

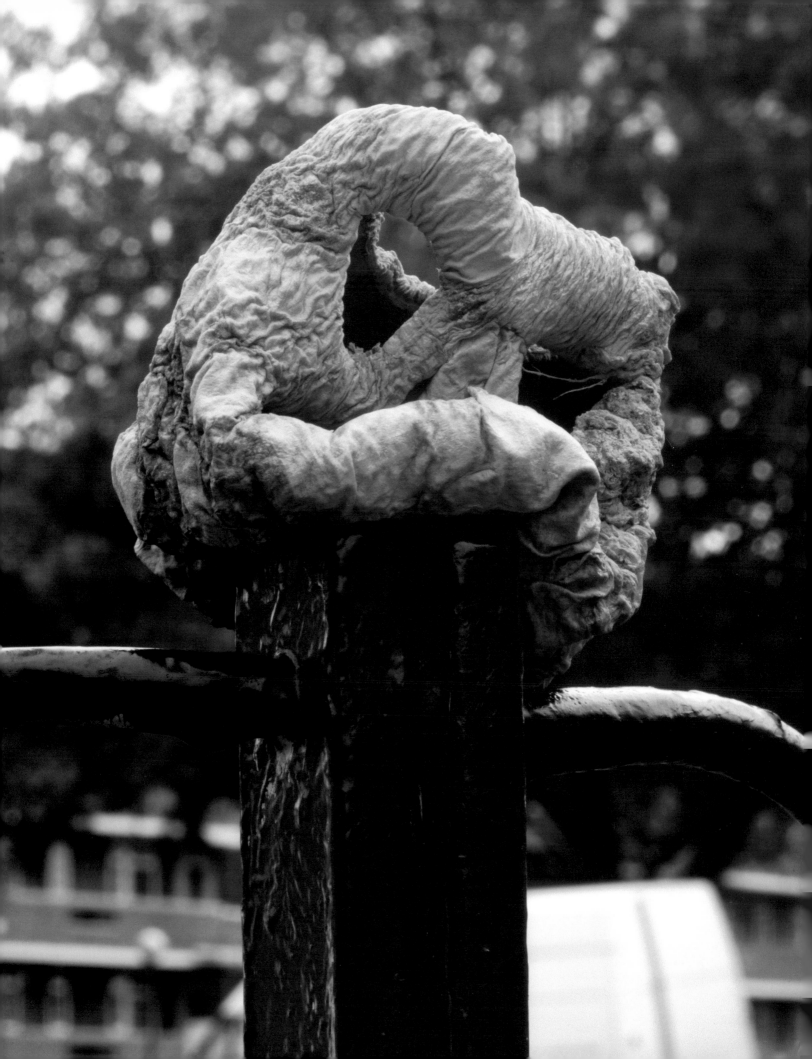

Stepped
2006, clothes-horse, string and polystyrene balls,
114 x 56 x 70 cm

OVERLEAF LEFT
Mr
2006, string wire, wood, cardboard tubes and plastic,
98 x 55 x 40 cm

OVERLEAF RIGHT
Temple
2003, metal plinth, wood and found objects,
84 x 46 x 31 cm

Anything more to say on collage?

I'm enjoying their formalist nature; some of the recent work has had a pseudo-narrative element to it. But I've realised that the images are interesting enough to not need the implied narrative, like an aeroplane in the background or horses galloping around.

And hence your interest in making straight sculptures and their rejection of narrative. Looking at the big sculpture over there; maybe that's the nature of objects anyway, always to prevent narrative, that's the only way we can understand something. Maybe it goes back to stopping when you understand something, at which point you're always looking for the next state of not understanding and that escape from narrative is precisely because, actually, narrative is there — its function is to make sense of things, even if it's non-sensical.

I might only have a small window of opportunity to make some sculptures before I understand them too well.

From there on you will be like Robert Ryman, making very pared down canvases, no narrative whatsoever thinking, "Why on earth am I painting like this? I'll carry on painting like this because I don't understand why I'm painting like this!"

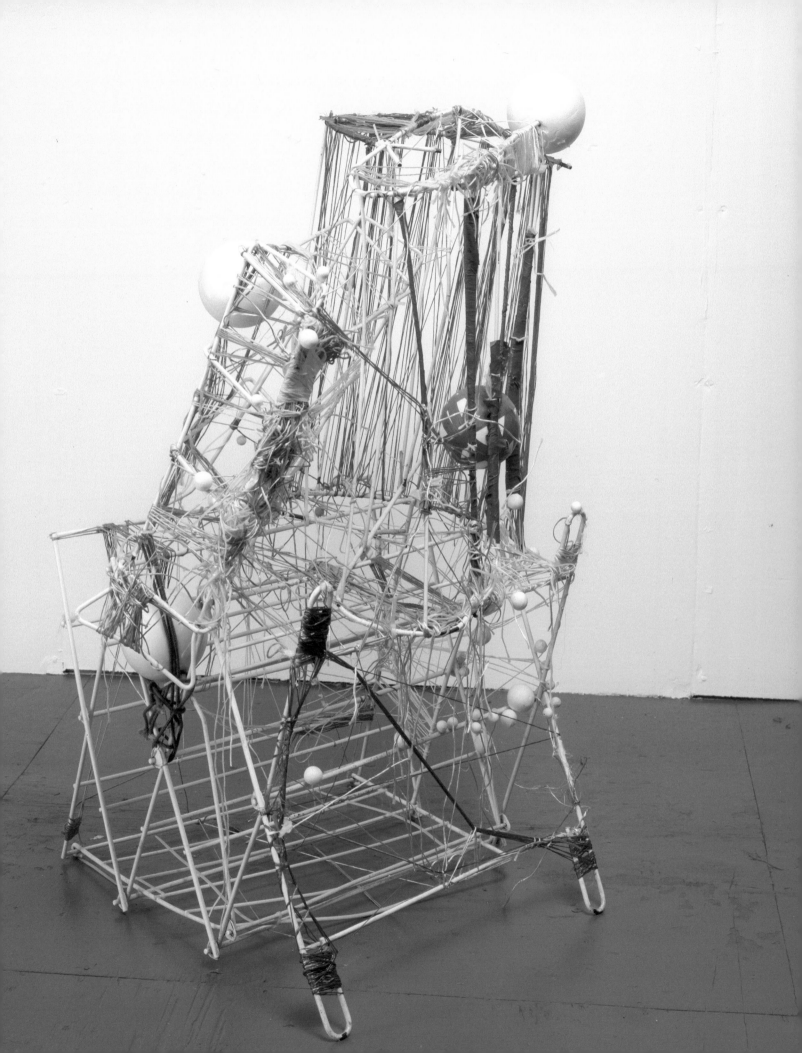

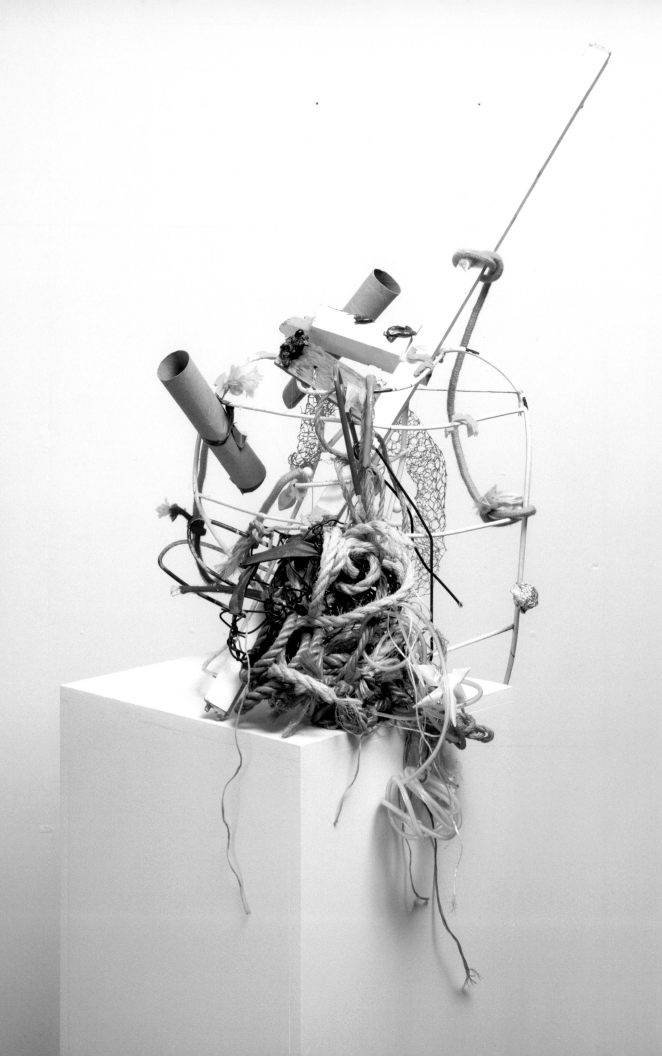

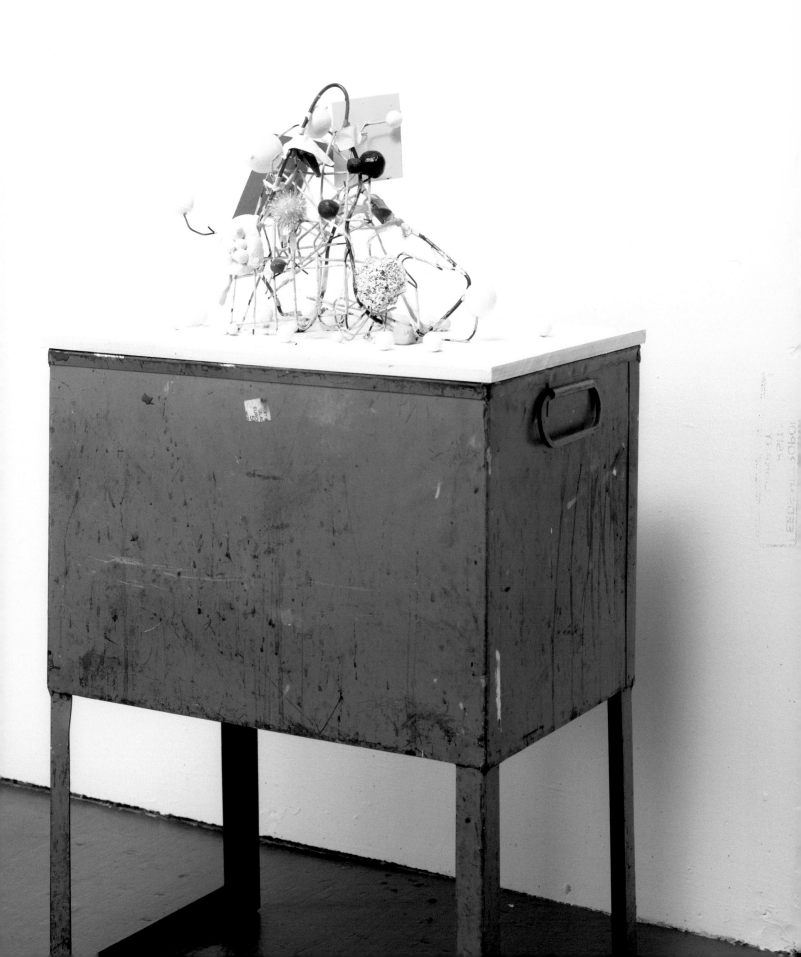

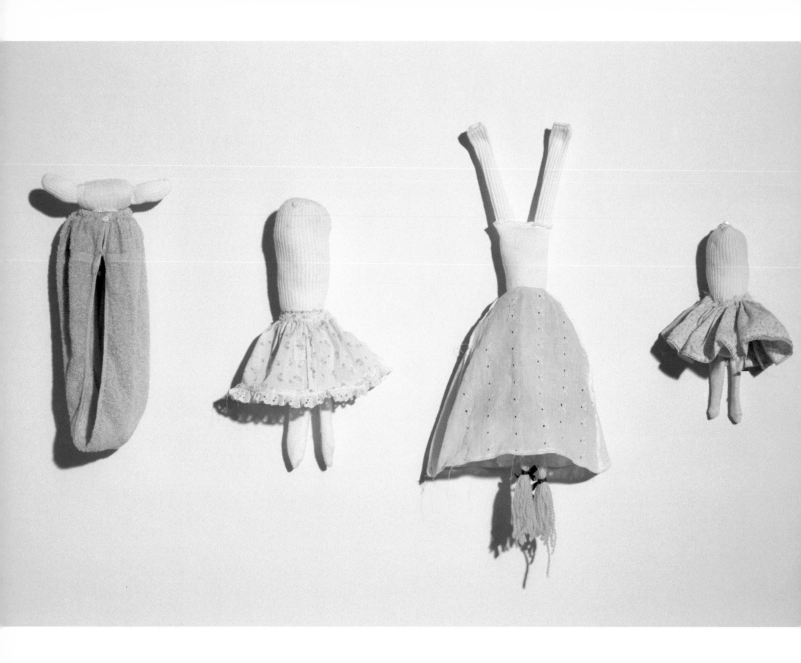

We should talk about my ambivalence to the genre of photo-realistic painting. You see the paintings firstly as photo-realistic, within quite a specific tradition, although its been complicated post-Richter. My interest in making something so mimetic is new to me; it's not coming from having a long-standing interest in photo-realist painting, which often seems like a scientific thing, certainly if you look at someone like Chuck Close. When I chose to make the paintings in this manner it seemed to be the simplest way to get these objects onto a canvas; a necessity if I was to escape the limitations of my previous technique which could only render lines due to the thickness of the paint. However, painting like this brings with it certain baggage, in particular a focus on technique rather than on that which is depicted. But of course, each position or method will have its own problems and failings; the painter has to live with this.

It sounds like you're quite defensive about the tradition within which your paintings could be seen.

I don't see it as my heritage. Where I've come from, I would say my roots, in terms of photo-derived painting, are more from Gerhard Richter than a Chuck Close trajectory; the relationship between the photo and the painting is much more distanced.

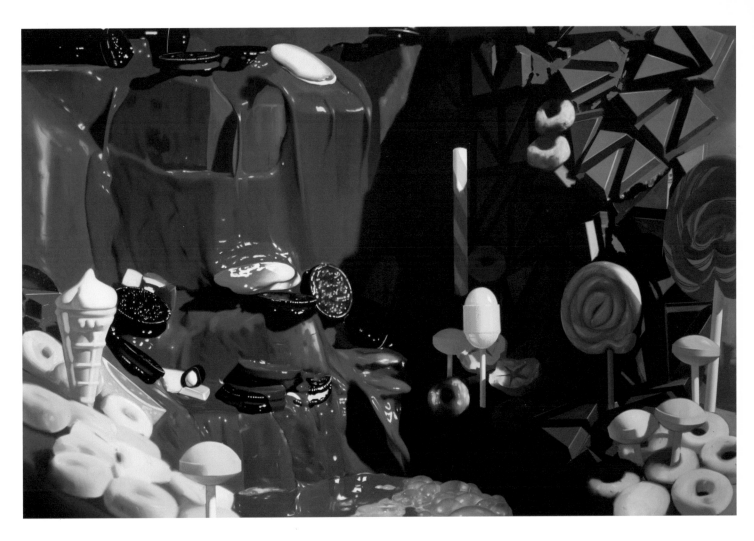

MIKE KELLEY
Four Sock Dolls
1990, mixed media, four parts,
dimensions variable

WILL COTTON
Devil's Fudge Falls
1999, oil on canvas, 244 x 366 cm

That then prompts the question, where do you see yourself? Both in terms of tradition and those artists you most admire now, those that you think, not just formally, but actually in terms of ideas — like the young sculptors you spoke about before — where would you place yourself?

I find myself more interested in people who you'd describe as predominately sculptors rather than painters; Mike Kelley for his interest in the uncanny, Fischli and Weiss for their playfulness and humour. As for painters in my peer group, painters who use photos, I'd say people like Andrew Grassie and Glen Brown are the most interesting ones that I'd feel more of a kinship with. In both cases the photograph is a means to an end, there's a conceptual framework for the work. I'm aware of a couple of artists working from photographs of models at the moment, Will Cotton in the States and William Daniels here. One is very American — rich and opulent, the other, very austere, perhaps more European. In Cotton's work, it seems to me that the model is very important; it allows you to enter into the fantasy because the landscape has been made before in real-space — there's nothing in the way. I'm just trying to make an interesting painting that happens to be derived from a photograph. Maybe I'm making a big song and dance about nothing.

**It gets you so far. A lot of people have that skill and make very un-interesting
work. It's more conceptual for you. What are you reading at the moment?**

> Non-fiction, Richard Dawkins, *The God Delusion*. But like a lot of artists, you
> get so tied up with fashion, what you ought to read. I mean I've found myself
> reading, in terms of novels, what artists should read!

Very mimetic!

> Yes, very mimetic, what *Frieze* tells you to read! Ballard, WG Sebald, Phillip
> Dick, I mean I could just say here I also listen to The Smiths and Joy Division!
> However, I do genuinely enjoy these authors. I've also read and re-read HG
> Wells and Jules Verne. I don't know how it feeds into the work. *The
> Upperworld*, as a title, is a direct quotation from *The Time Machine*, although
> it's not an illustration. The surrealist Ballard stuff from the 1960s and early
> 70s is, maybe, pertinent in some sort of way; his juxtaposition of the everyday
> and the surreal. But I don't read in order for it to feed into the work.

**What's curious, and it's just struck me now, is that *you* seem to be missing from
the whole of this interview! It's like, "I should be doing this for the work, the
painting." To get a sense of you, yourself in relation to the world around you
— you've spoken about being at home making these models — but beyond that,
your taste, where you'd like to be, those kind of things, are completely absent.
Is that because you subsume yourself through your work, or see yourself
through your work?**

> I am my work; the Protestant work ethic demands it of me! Perhaps I do see
> myself in the objects, although it's a scary thought that they are self-portraits.

I'm not suggesting they are, you don't have to be there!

> I think I'm there. It's important; partly it's about extricating me from this modernist
> trajectory we talked about earlier — the non-personal, the theoretical. When I
> made the rollercoaster paintings, perhaps my first found object and a tentative
> early move into representation, it became more personal, nostalgic almost. The
> rollercoaster was from my home town of Aberdeen, a childhood thing, a personal
> thing, I'd used it as an undergraduate, it was totemic. With the new work the
> kids' toys are my kids' toys...

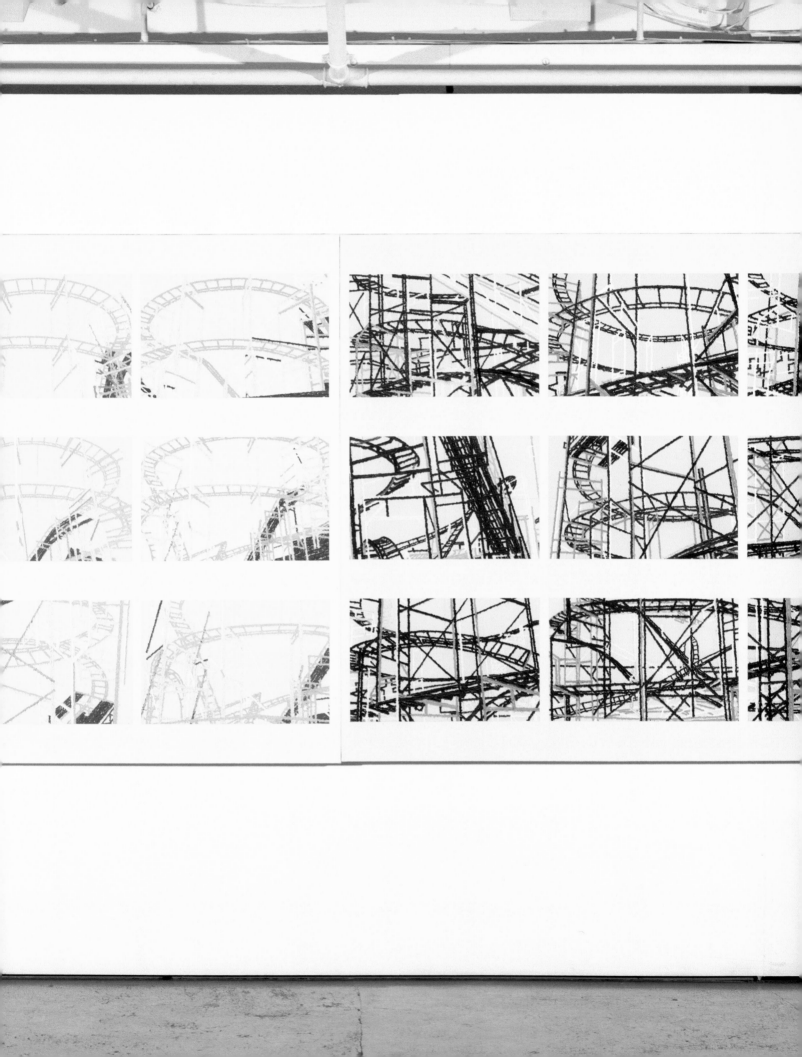

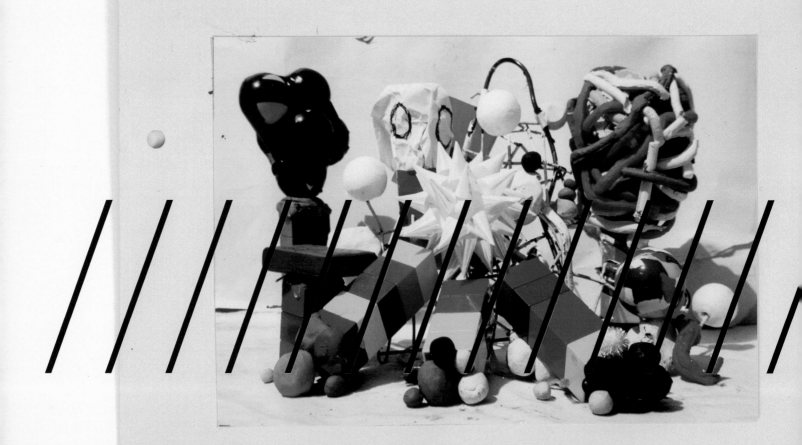

WORK
BOOK

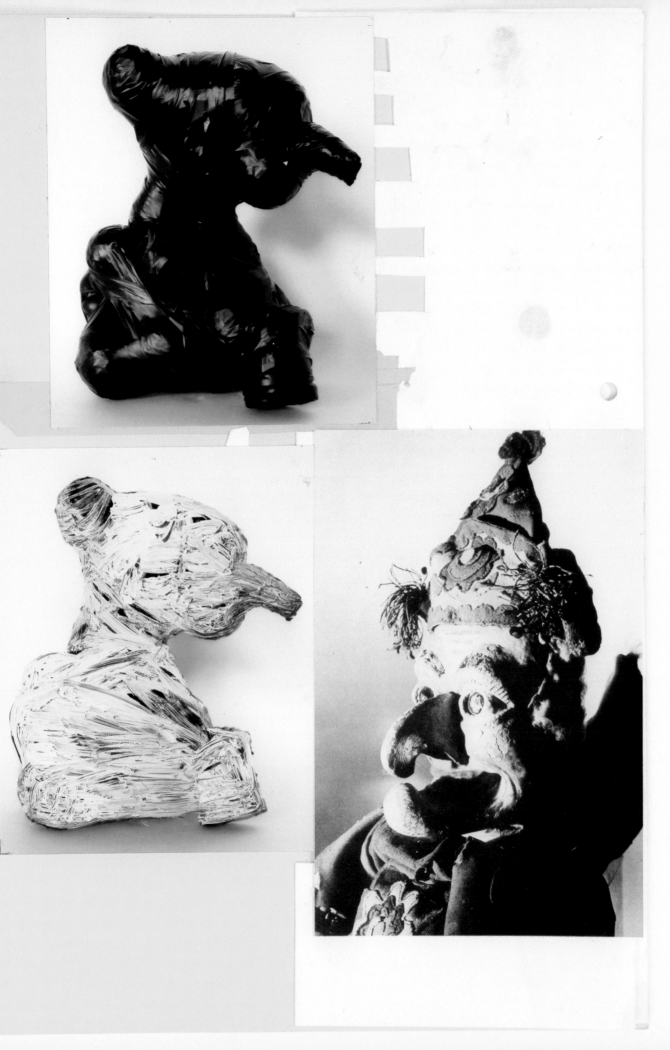

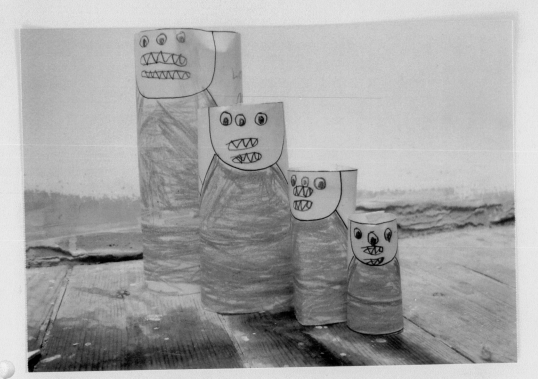

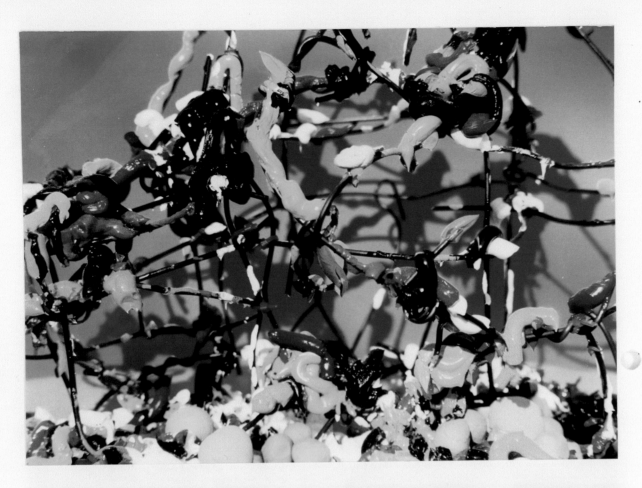

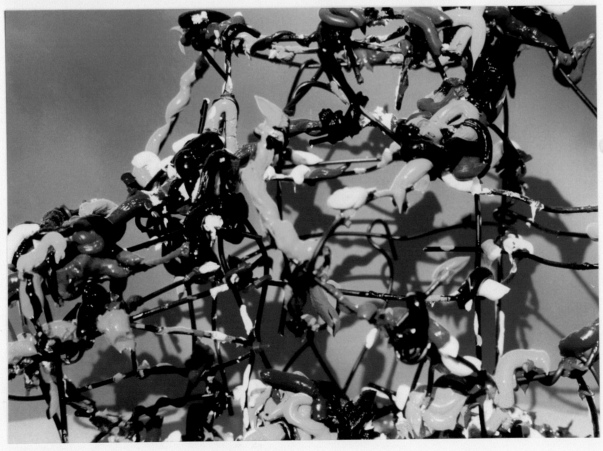

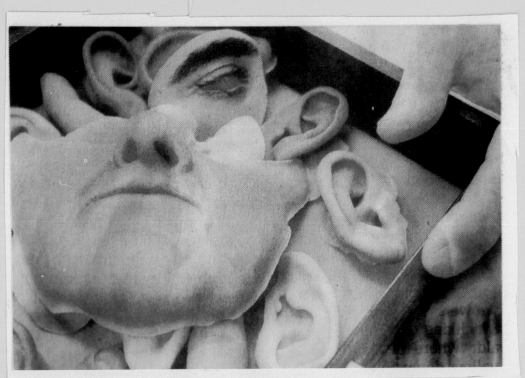

COOP HIMMELBLAU. WHITE SUIT. 1969.

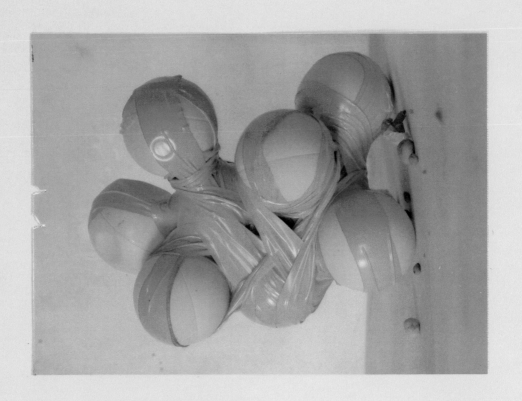

61 The second scene from the 'Triadic Ballet', 1926 p

March 06

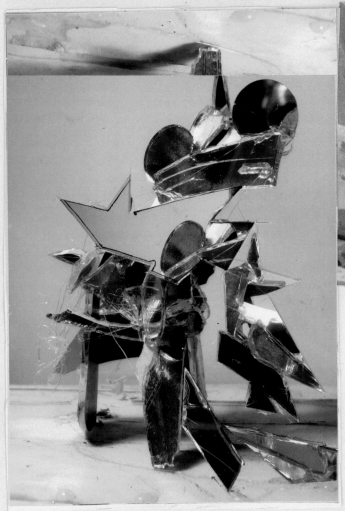

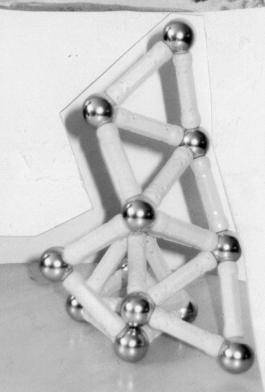

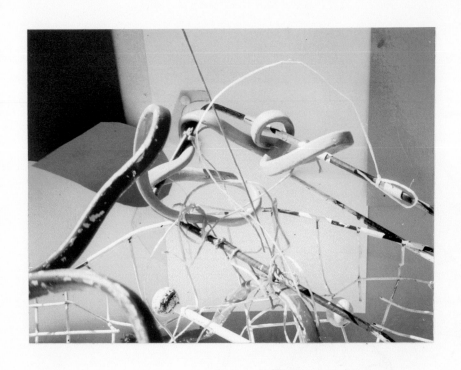

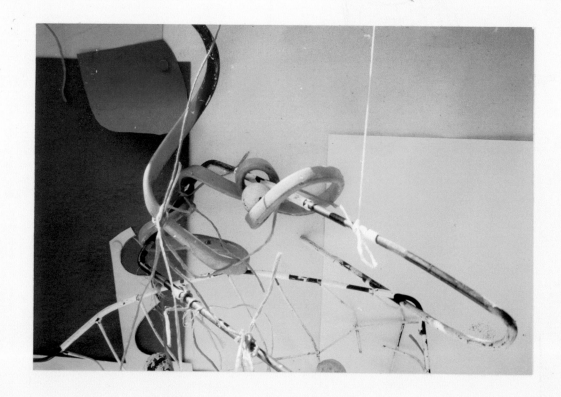

7 X 10 FT 15 FT

CUT

edge off — not full basket
cropped

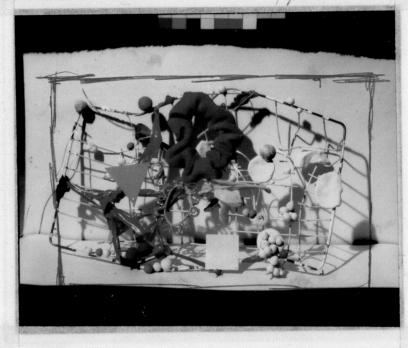

MAKE
SURE
NO
REFLECTION
ON
YELLOW
SQUARE
✳
OR
TRIANGLE.

programm... ...woodland...

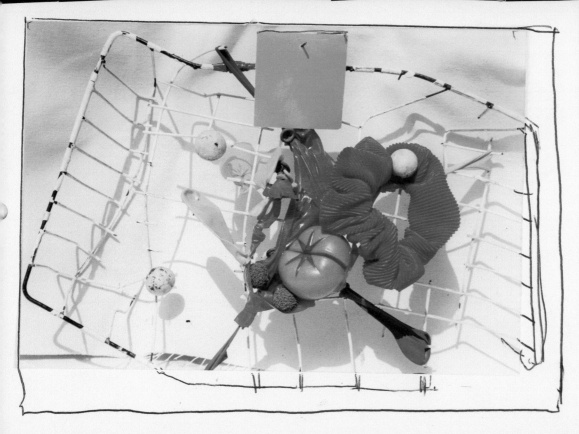

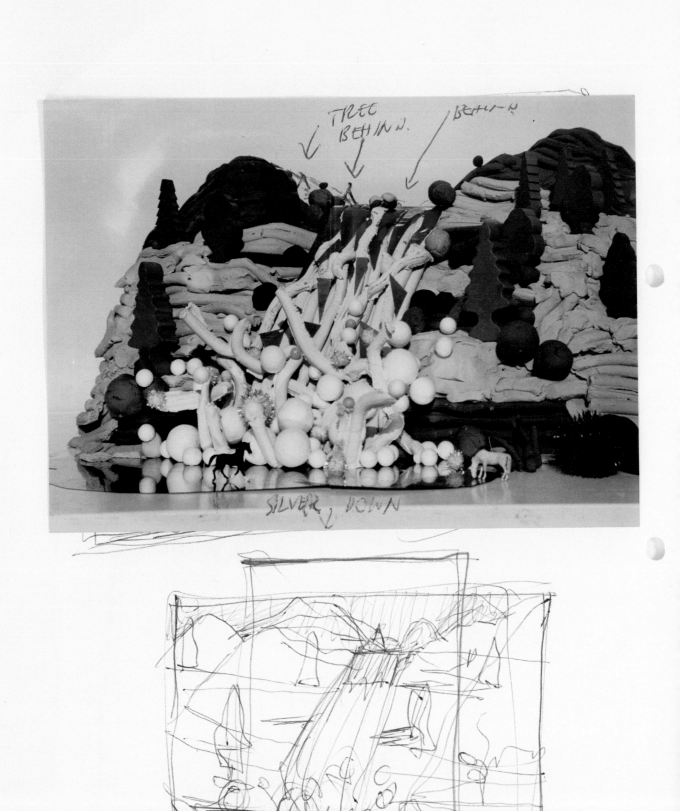

vertical
not landscape
waterfall.

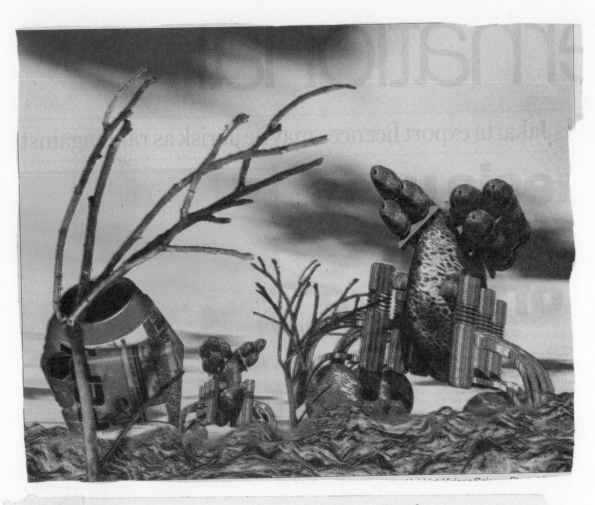

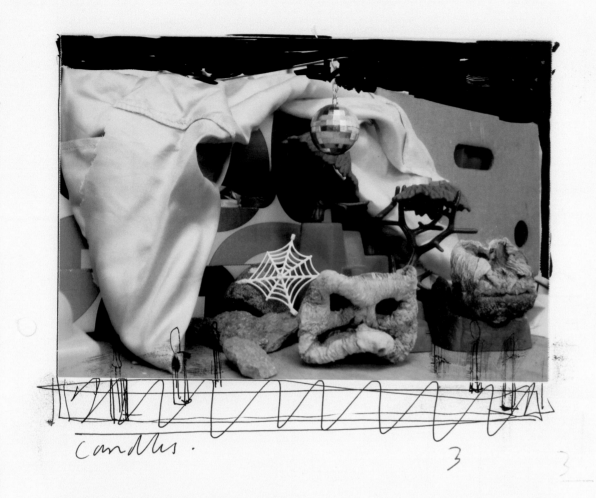

candles.

3

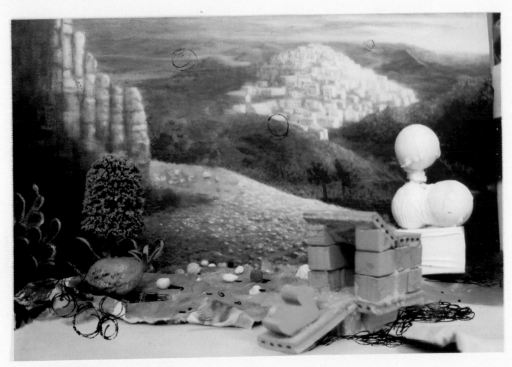

— maybe flowers foreground?
— move things around
 still too flat. too frontal.

johanna malt//

VISIBILITY AND THE SEEN

Tyburn
2006, oil on linen, 102 x 81.5 cm

However strange the objects they show us, Neil Gall's paintings are always showing us something. Magnifying the scale so that every tiny detail of an object can be captured, they seem like intricate and methodical investigations of aspects of the real our own perception can often miss. The things subjected to this treatment seem equally worthy of attention, whether they are as ordinary and familiar as toy farm animals, chocolate bars and burst balloons, or as creepy and hard to place as the bound black figures of works like *Tyburn* and *Performance*. The paintings draw us in through illusionism and recognition, whilst always reminding us of what we can't recognise and don't see. And their apparently straightforward concern for photo-realist accuracy and transparency belies a complex set of paradoxes that intersect within them. Detached and observational on the surface, they are in fact bound up with layers of fantasy and with what they can't show us about the objects they rigorously display for us to see.

STILL LIFE/LANDSCAPE Two modes are identifiable in Gall's paintings. Much of the time they operate in the tradition of the still life. They seem to depict, with meticulous verisimilitude, an object or group of objects laid out in a particular arrangement or orientation for the purpose of being painted. The backgrounds are often neutral but perspectively coherent, with a horizon where the horizontal plane on which the objects rest meets the wall behind. Even for the viewer unfamiliar with Gall's working processes, there is a strong sense of the objects being 'staged' for their representation, sometimes in quite literally theatrical, as well as painterly ways. The lighting is deliberate and directional, with shadows adding to the complexities of form, texture and materiality which the paintings explore. The objects depicted may gesture towards chaos, but the compositions are artful, harmonious and rather calm.

Yet there are times when this sense of dramatic staging gives way, or rather tips over into another mode. It is as if the wire frameworks present in the earlier still-lifes (such as *Cast* and *The sooner you get away from here the better*) could develop in two different possible directions: either as literal, formal structures or as metaphorical structures of fantasy. They could organise the picture surface as analytical formal devices or as webs of the imaginary, memory, or desire. In this latter mode, the paintings come closest to Surrealism in their creation of a perspectival but metaphorical space: an inner vista, a landscape of the mind. In this mode, the limits of the painting delineate a defined other world, one that ought only to exist in fantasy, or is at least governed by the laws of the imagination.

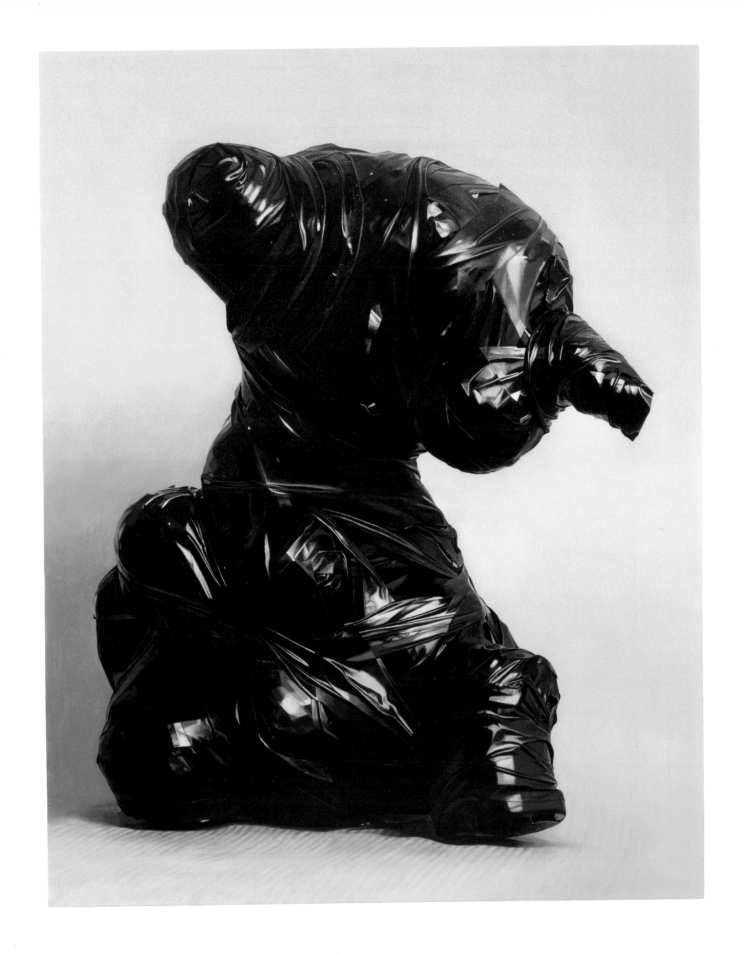

71

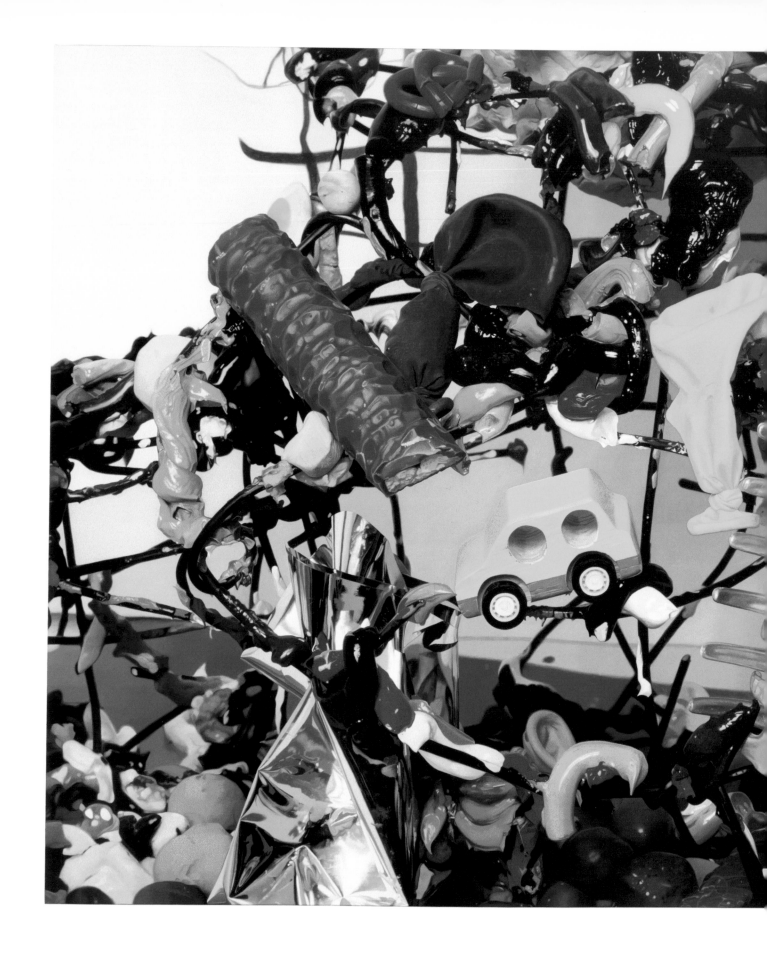

johanna malt **VISIBILITY AND THE SEEN**

YVES TANGUY
Day of slowness
1937, oil on canvas, 92 x 73 cm

1_Salvador Dali, *Geological Destiny*, 1933.

In Surrealist painting, these laws can sometimes structure the painting quite literally. The rules of perspective which establish a certain spatial relationship between say, a horse, a giant egg, two human figures and a rock, stand in for the forces that configure such images within the space of the mind.[1] In the work of Salvador Dali, Yves Tanguy and René Magritte in particular, even when the objects lurking in a landscape are not recognisable forms but formless blobs of indeterminate matter, the organising principle of perspectival space keeps order, not because these objects could exist concretely in a perspectival real, but because the interior space being represented here has its rules too, and perspective acts as a shorthand for them. Gall's work comes close to this mode at times, offering fantastical landscapes inhabited by both recognisable creatures and unreal forms (as in *The Upperworld* or *The precipice*, for example). But what is most interesting about the way in which it relates to such traditions is the tension, or oscillation it sets up between them.

In the most obviously 'still life' paintings, staging and technique conspire to convince us of the real existence of the thing. Even where the object depicted is unrecognisable, baffling or mysterious, it is nonetheless so 'lifelike' that it must in some sense be real. Details such as the highlights on a glossy blob of semi-transparent glue, the exact way a plastic hairclip or the surface of a Twix reflects the light, can only be divulged to perception, not to the imagination: in short, you couldn't make it up. At this level we read the painting as a photo-realist document, even when we can't identify the thing being documented. And indeed, some of the paintings betray the literal presence of a photograph, mediating between the staged objects and their representation in paint. In *Descent*, for example, the horizontal surface goes in and out of focus as it recedes from the foreground. This is not an effect created by direct perception with the human eye, but the evidence that we are in fact seeing through a lens, which cannot record this three-dimensional tableau in uniformly sharp focus. The painting represents this effect, making clear to the viewer that what is being recorded is already a recording: this is a painting of a photograph of a thing, and we are at not one, but two removes from the object itself. The same effect is seen in *Moose*, where the varying focus implies the mediating presence of a lens.

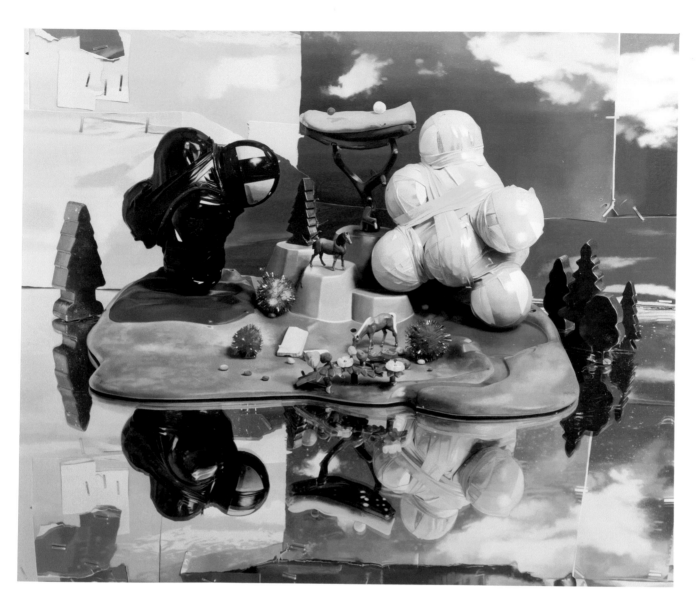

The Upperworld
2005, oil on linen, 183 x 224.5 cm

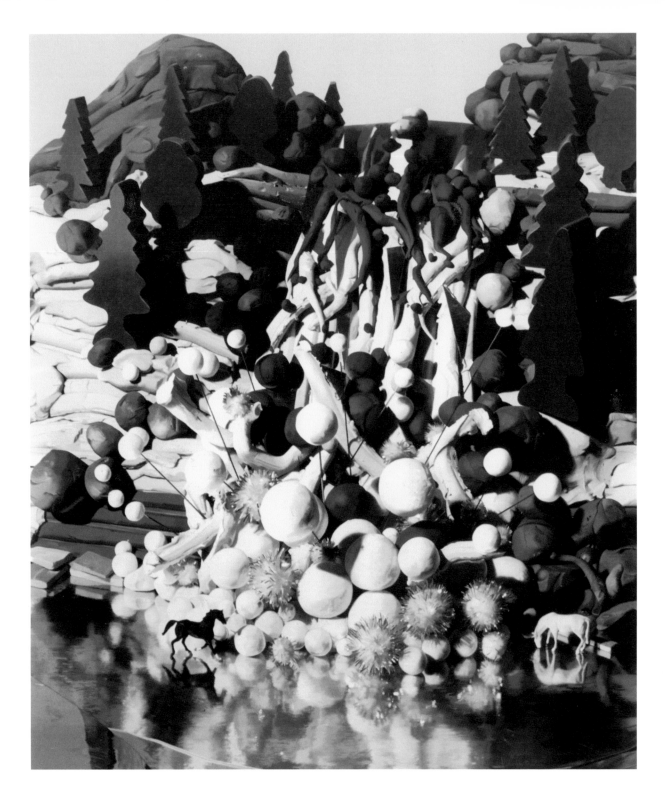

The precipice
2003, oil on canvas, 213.5 x 183 cm

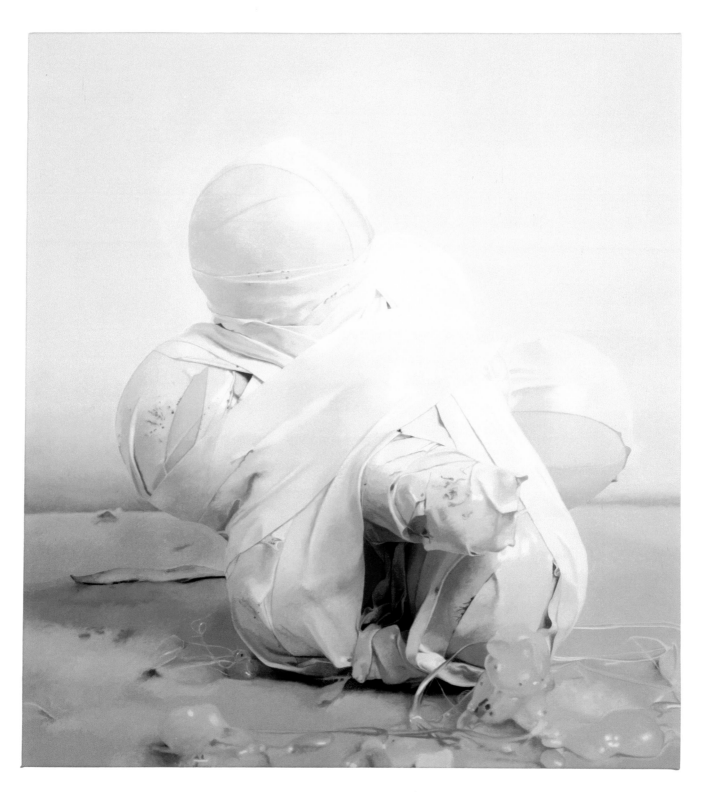

Descent
2004, oil on linen, 66 x 61 cm

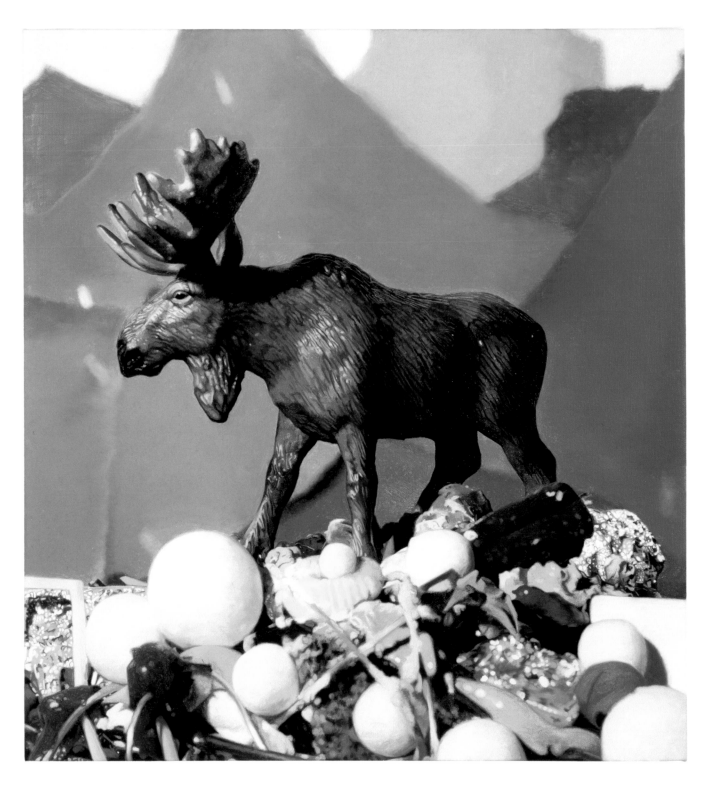

Moose
2005, oil on linen, 76 x 71 cm

johanna malt **VISIBILITY AND THE SEEN**

2_Published in *The Originality of the Avant-Garde and Other Modernist Myths*, Cambridge, MA: MIT Press, 1985.

3_The terms are taken from the work of the American philosopher and mathematician CS Peirce.

4_Roland Barthes, *Camera Lucida*, trans. Richard Howard, London: Cape, 1982.

In a seminal article entitled "Notes on the Index: Seventies Art in America", Rosalind Krauss explores the increasing dependency of art on the conditions of photography.[2] It is not just that photography and film themselves have become increasingly prominent 'high art' media, or that certain contemporary forms such as landscape or performance art often depend on photographic (or filmed) records to some extent. It is not even that painting persists in some rivalry with photography over mimesis. For Krauss, 70s art increasingly aspires to the status of the photograph as index; or rather, it reduces itself to it. Rejecting iconic representation, which signifies through resemblance, and symbolic signs which are products of some collectively agreed language or code, artists seem drawn towards signs that work by mere physical proximity, that are, like photographs, indexes of a moment of presence.[3] For Krauss these signs work like the shifters, or 'empty' signifiers of language such as 'this', 'I' and 'you'. They are meaningless except by their co-existence with something else; with the thing designated as 'this', the person who says 'I', the presence which left an index or trace as its sign. As Roland Barthes points out in a famous essay on photography, all photographs work this way.[4] The one thing they are all always saying is *ça a été*, this *was*. It was light bouncing off the object and hitting the light-sensitive surface that made the photographic record. To the extent that they seek to follow this logic then, works of art signify by pointing, by saying simply 'this'.

Krauss includes photo-realist painting in her discussion of the rise of the index, and insofar as they concede to the photographic record, Gall's works might be viewed in this light. Looked at this way, their interest would lie in the way they offer documentary reliability (this *was*), in the face of apparently impossible objects. In asserting their 'photographic' veracity, they force us to interrogate these unrecognisable things that must nonetheless have been.

79

Skull
2004, oil on linen, 61 x 51 cm

But Gall's paintings never reduce their objects to statements of pure facticity, because of the other life those objects have in the domain of the imaginary. The paintings' (or rather photography's) indexicality may anchor us in the realm of the still life, but this is a realm against which the objects depicted revolt. Their indeterminacy opens up a world beyond the record of what was, allowing us to reframe the space in our mind as the fantasy landscape of the 'surrealist' mode described above. And what is important is that neither reading cancels the other out. We may know very well that these are depictions of plastic balls wrapped in different coloured tape, but this knowledge can co-exist with any number of other interpretations of the work.

And this co-existence works equally the other way. In the works which offer the most complete constructions of imaginary worlds, it is often the moments of recognition that puncture the imaginative reading. Perhaps the most surrealist of all Gall's paintings is the invitingly entitled *Materials for reasoning*. While its dramatic chiaroscuro and black background evoke much earlier traditions, it also strongly recalls Dali's beach landscapes of the mid-1930s, with long shadows cast by the formless yet intricate 'figures' that sparsely populate the sandy-coloured ground. These are not found objects, but forms moulded out of formless matter; they are unrecognisable, yet the specificity of their morphology and configuration seems to imply some hidden meaning. What breaks this mode of imaginative interpretation is the edge, not of the painting itself, but of the horizontal surface, which the foreground reveals as a sheet of brown paper, whose torn end wraps towards us over a table's edge. Like a second horizon, the line formed by this edge is a kind of tipping point, a watershed between imaginative fantasy and recognition in the real. Similar axes exist in *The precipice* and *The Upperworld*, where nature appears through forms that are recognisable as manufactured objects — as little toy animals and stylised, cookie-cutter trees. And in fact, even the formless matter out of which objects such as the *Skull* are created is instantly recognisable to anyone who has ever played with plasticine. Recognising these things pulls us back towards the still-life, towards seeing a staging created outside the painting and then meticulously represented within it. The question of where the fantasy is — whether in the world of the painting or outside it — is a more interesting one than it may first appear, and it is one to which I will return.

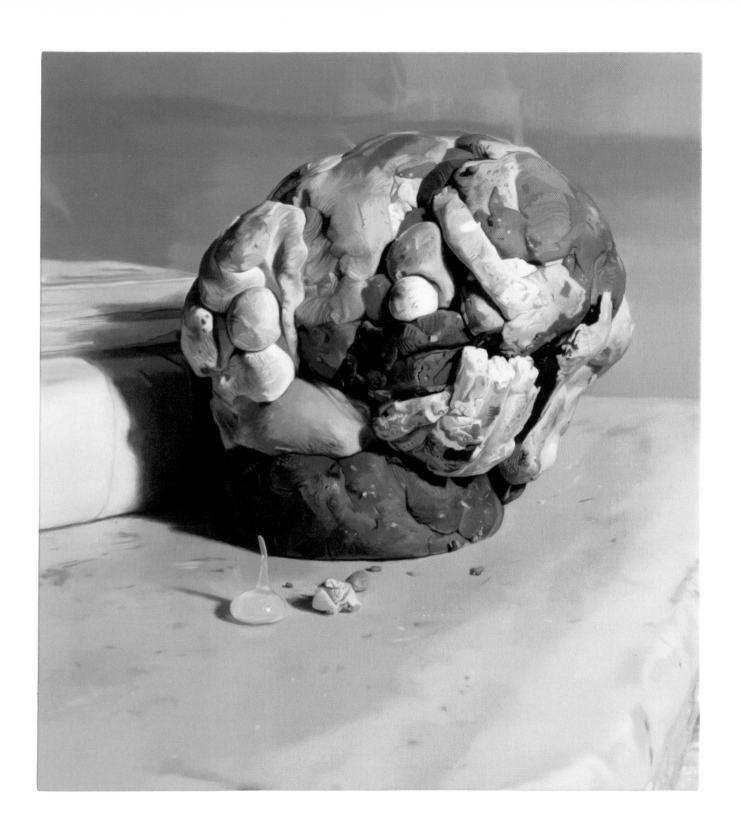

81

Materials for reasoning
2005, oil on linen, 109 x 147 cm

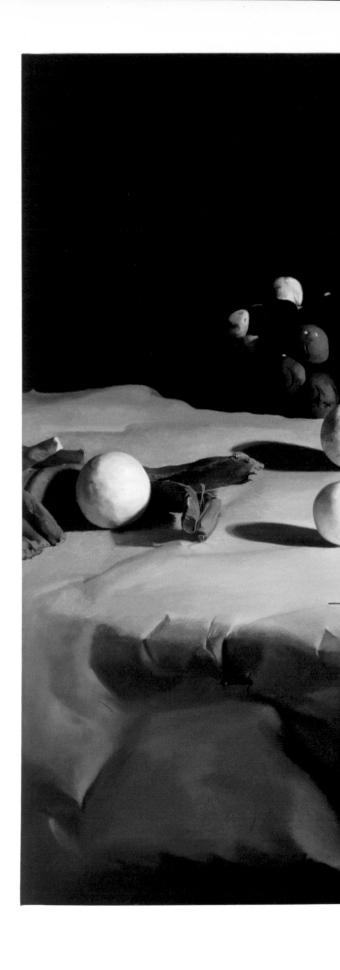

johanna malt **VISIBILITY AND THE SEEN**

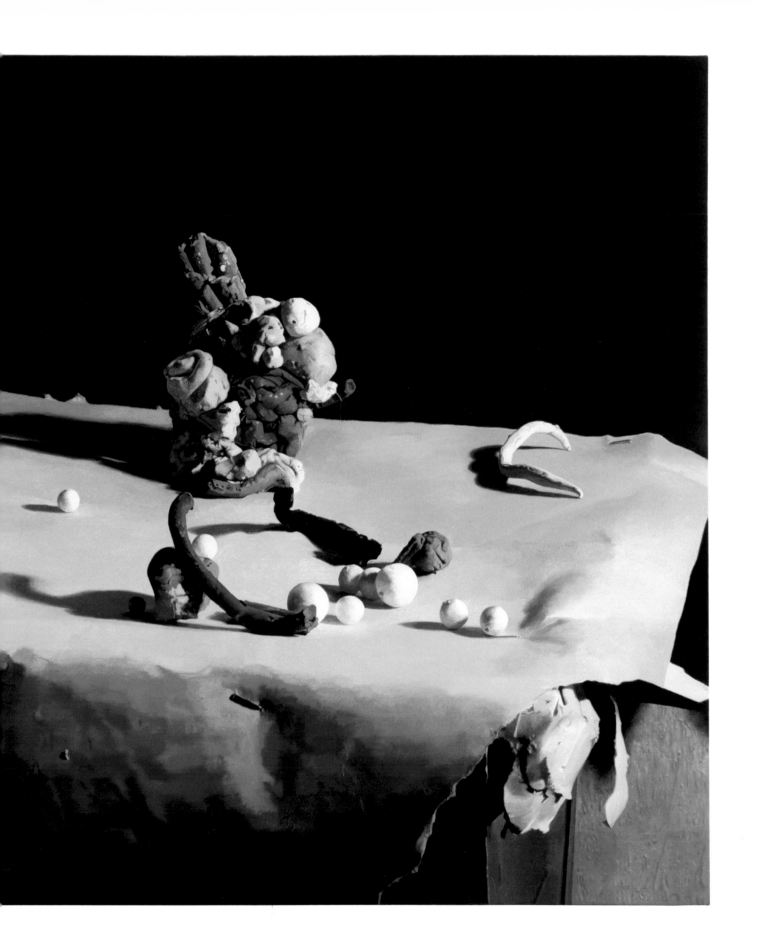

FETISH Looking at works such as *Performance*, *Tyburn*, and *Descent*, the term 'fetishistic' easily comes to mind, and it turns out to be an appropriate description on several levels. In contemporary use, the word has become so commonplace as to be almost meaningless, signifying little more than a fondness for shoes or the tactile qualities of certain materials. On the other hand, in the context of the fetish 'scene', it has come to designate a rather narrower and increasingly more commodified spectrum of behaviours than it might originally have described. Fetishism in this sense has its uniform of rubber, leather, black PVC, its customs of revealing and concealment, its connotations of contained violence or constraint. A work like *Tyburn*, whose title, referring to the infamous London place of execution, underscores its potentially dark and violent connotations, invites these kinds of fetishistic associations. We know it isn't a human figure bound in this sinister and mysterious way, but at the same time we can't quite give up the human associations, and the rather disturbing effect those associations produce. The object in *Descent* isn't bandaged, drooping human flesh, but that suggestion, created in the first glance, nevertheless persists. And it is this effect of making us continue to suspect what we know to be untrue, making us believe and at the same time doubt the evidence of our perception that is in fact the most fetishistic thing about Gall's work.

5_Sigmund Freud, "Fetishism" in *The Standard Edition of the Complete Psychological Works*, vol. xxi, ed. and trans. James Strachey, London: Hogarth Press, 1961. The term was originally coined as describing a perversion by Krafft-Ebing in his *Psychopathia Sexualis* of 1886.

In his essay on fetishism, Freud notes that no patient has ever come to him wishing to be cured of his fetish.[5] Fetishism as a clinical condition is not experienced as particularly problematic because it turns out, according to Freud, to stem from an extremely powerful mental strategy which the fetishist has no incentive to give up. This strategy — disavowal — is, put very briefly, the ability to hold two contradictory beliefs simultaneously without being forced by the contradiction to give one of them up. In Freud's original essay it applies specifically to the ability of the fetishist to know, on the one hand, that the woman does not have a penis, and on the other, to persist in believing she does, co-opting the fetish object as a kind of evidence for the latter belief. Disavowal is what allows desire and anxiety to coalesce around the same object because the fetish always serves a dual purpose; it conceals a lack, or the site of violence (originally castration), yet by the act of standing in for the absent object it draws attention to the very loss it seeks to hide. This logic of concealment and commemoration, of the object used as a prop to incite desire whilst revisiting loss and anxiety, has given fetishism considerable success as a critical concept, notably in film theory and cultural studies.[6] Its strategy of disavowal seems to have a resonance that makes fetishists of us all, and it offers one interesting way of seeing the oscillations in Gall's work between anxiety and familiarity, between playfulness and menace, between the mode of recognition and that of fantasy.

6_See, for instance, the work of film theorist Laura Mulvey. A useful overview of critical uses of the term is offered by Emily Apter and William Pietz, eds., *Fetishism as Cultural Discourse*, Ithaca, NY: Cornell University Press, 1993.

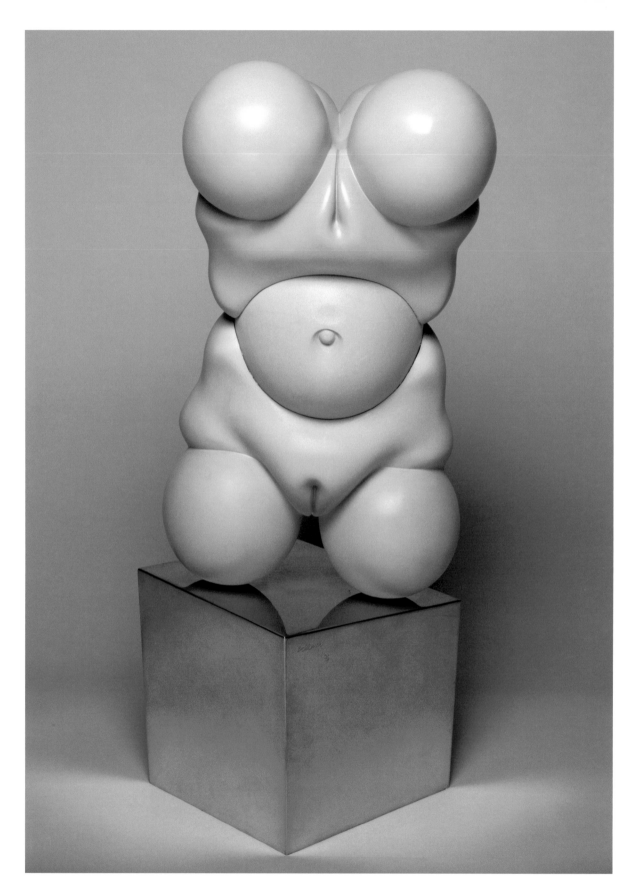

HANS BELLMER
The doll (torso)
1935, remade 1965,
painted aluminium on brass base,
63.5 x 30.7 x 30.5 cm

johanna malt **VISIBILITY AND THE SEEN**

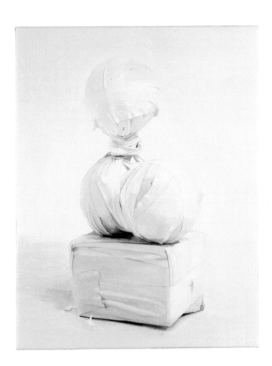

Such a contention is strengthened by certain resonances, particularly in the works featuring taped clusters of balls, of that most fetishistic of artists to be called Surrealist, Hans Bellmer. The multiple globular protrusions of Gall's 'figures' evoke Bellmer's dolls, especially their more abstracted manifestations. The painted aluminium Doll piece Bellmer contributed to the 1936 Surrealist exhibition, now known through later recreations, dispenses with head and limbs altogether, articulating the reversible torso with an enormous ball joint, with similar balls protruding from the hips/shoulders (indeed, the work was apparently first known under the title *Ball Joint*). Other versions of the doll see proliferations of these spherical outgrowths, which are sometimes breasts, buttocks or ball joints, and sometimes simply unexplained protuberances. Mediated as they are by the inanimate workings of dolls, and often by the photographs through which we know them, these works nonetheless make reference to a point of origin in the human form. And reading Gall's work in the light of these resonances reinforces the persistent human quality the objects continue to have, despite the clinical and detached neutrality with which they are represented to us as inanimate material fact.

Bellmer's work has itself been understood as fetishistic in more than just the obvious ways. A further dimension is offered if one follows the move made by Jacques Lacan in making explicit the implicit distinction in Freud between the real penis and the phallus as symbolic object. For Lacan, the symbolic phallus is the 'privileged signifier', signifying in fact the whole of the symbolic system (language, social structures, laws, the system of exchange) into which we must all enter in order to become subjects, but which we enter at the cost of a pervasive loss. This loss is itself a symbolic 'castration' by which we are cut off from our imaginary, whole version of our self; entering into the symbolic we must renounce this fantasy of being or of possessing a true object of desire. Instead we find ourselves within an economy of desires that are never — and can never be — satisfied. It is the symbolic phallus that anchors us in this system, signifying the desire which motivates it, but of which all objects fall short. Castration and fetishism take on particular significance in this light. The fetishistic profusion of signs or signifiers on the surface of the dolls' bodies (and echoed in Gall's taped ball figures) can be seen as a futile but repeated attempt to make the object coincide with the lack-driven desire that the symbolic phallus signifies. The body becomes covered in a profusion of phallic signifiers which only emphasise its inability to *be* the phallic signifier, to be the object of desire.

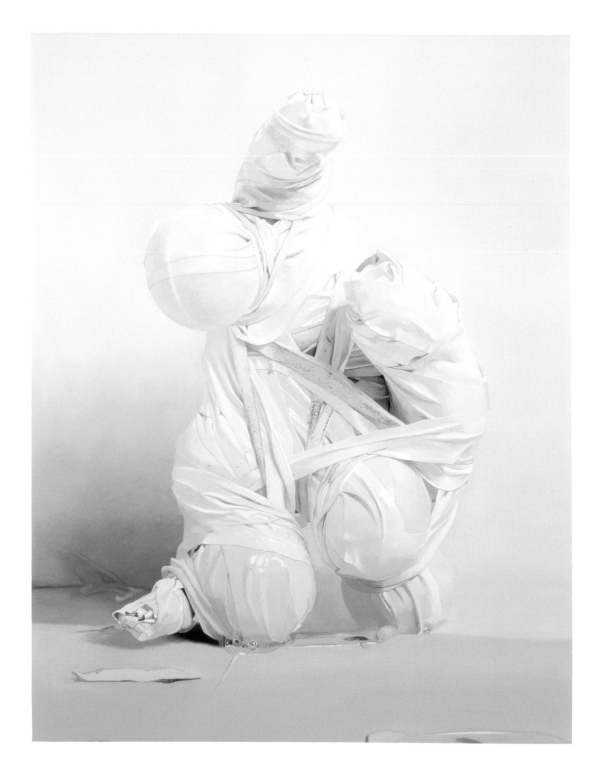

Imposter
2005, oil on linen, 71 x 57 cm

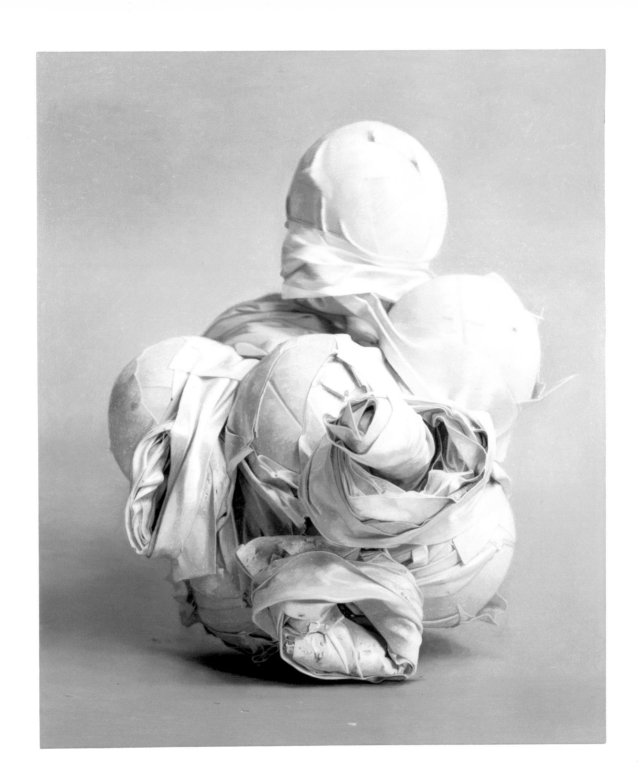

Bloc
2006, oil on linen, 66 x 56 cm

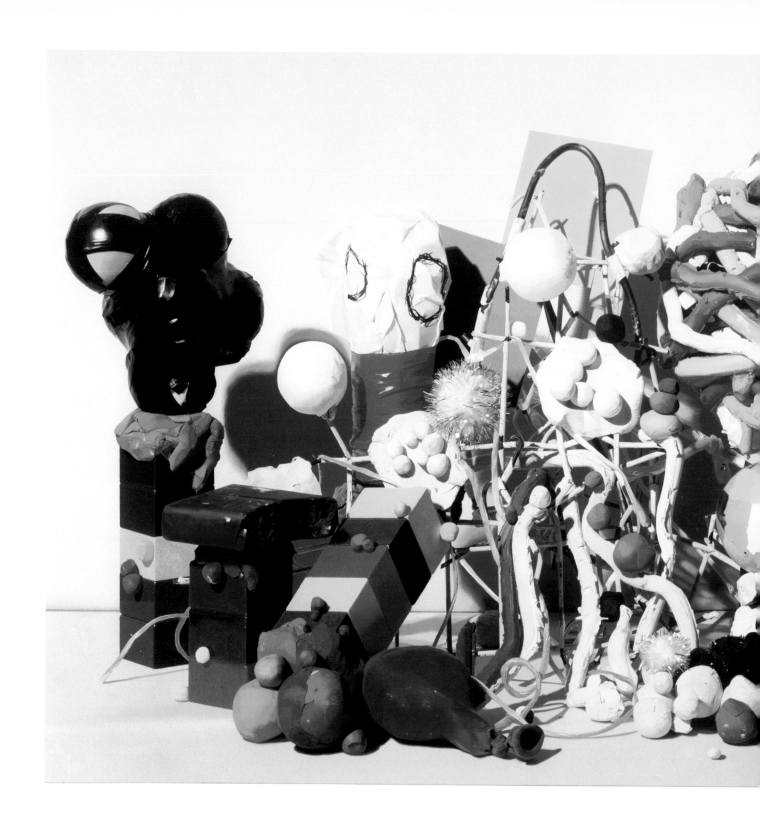

But yet another dimension of fetishism in Gall's work offers a note of irony in response to these concerns. This is most clearly demonstrated by looking at the two works entitled *Performance*, both of which feature the same object: a cluster of balls encased in shiny black tape, with just one, somewhat fleshy pink ball protruding, only partly concealed. In the 2005 painting, the object appears on its own, isolated and presumably magnified, though as with other paintings of this type, the indeterminate scale is significant. In the other painting however, it is just one of innumerable objects in a still-life arrangement, composed around a wire framework and featuring amongst other things: Lego blocks, balls and strings of multi-coloured plasticine, small glittery pom-poms and a deflated balloon. Most immediately, this takes us back to the dialectic of recognition and fantastical estrangement explored above. The juxtaposition with these more mundane, familiar and playful items renders the taped balls far more innocuous, revealing their true, rather tiny scale and inserting them, at first glance at least, into a much more manageable context. If this object is a kind of fetish here too, it is of the original totemic kind; a little personification, a pocket deity. There is something almost cartoonish about the way the object is posed in the latter painting, resembling a human figure perhaps more than ever, but this time as something like a blobby little cartoon character standing on one leg. The title of *Bather*, which features another single taped ball object, this time using balls and tapes of various colours, casts its own figure as a human protagonist too, recalling Picasso's variously monumental, explosive and ecstatic versions of that subject. In these works the objects are made to perform, like actors in a fantasy drama going on inside Gall's head. But their agency always has a comic element in this mode, one that playfully undercuts their more sinister appearances elsewhere.

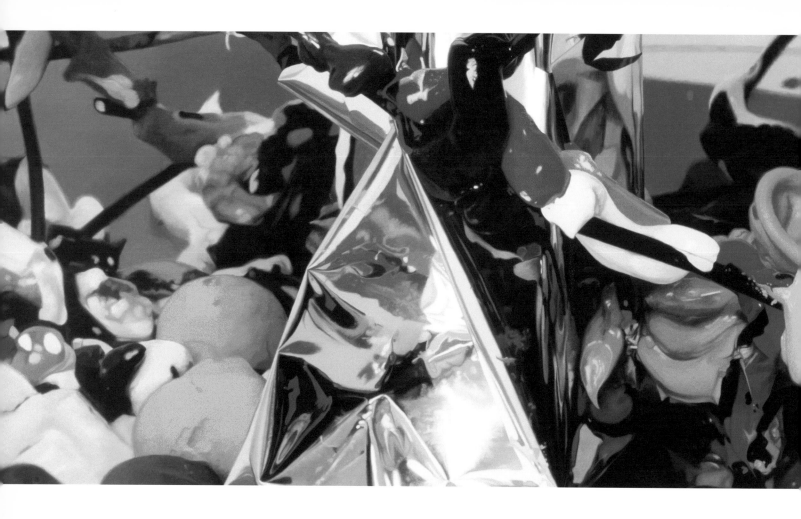

THE (SECRET) LIFE OF THE OBJECT

There is something particularly child-like in the way Gall's painting treats objects, and this is not simply due to the kinds of objects he chooses to depict. It is true that his earlier, more abstract wire models began to become populated by a chaotic explosion of objects sometime after he became a father. Some kind of transition is evident in a work such as *Cast*, where this idea of populating the painting space seems almost literal, with a line-up of abstract forms and familiar objects vying for attention on the deformed mesh structure that underpins the composition. *The sooner you get away from here the better* pushes this idea of an invasion further, with its mass of ephemera — blobs of paint and plasticine in bright primary colours, scraps of shiny paper, burst balloons, a half-eaten chocolate bar — causing the squeamish sensation of being overwhelmed by a chaotic mass of meaningless and rather too vivid matter. It's like the jaunty but slightly unpleasant detritus that might gather at the bottom of a child's toy box.

7_Walter Benjamin was particularly interested in the insights childhood offered into history and the commodity for this reason, since to the child, all objects are equally new, whether ancient or invented yesterday. The child does not (at least at first) inherit a symbolic value for objects, but will eventually create his or her own. See Benjamin, *The Arcades Project* ed. Rolf Tiedemann, trans. Howard Eiland and Kevin McLaughlin, Cambridge, MA: Harvard Belknap, 1999, pp. 390–391.

But the child-like perspective lies more than anything in the lack of distinction made in the works between different kinds or categories of objects. Home-made personal totems co-exist happily with manufactured ones that have a collective, social status as commodities. Just as in a child's fantasy games, any available object can participate on equal terms. No distinction is made as to scale, origin, material, status or intended use. Such a world can incorporate ready-made representations, of varying degrees of realism, alongside found objects and self-created ones, because no object is irrevocably tied to a single practical use or symbolic value. All objects are innocent in this world of childhood imagination, and it is a world we recognise in the paintings, even though we may long since have left it behind.[7]

When we see with adult eyes, manufactured objects often have particular roles in the paintings, beyond the work they act as recognisable tokens of the real. Firstly, they serve as moments of formal cohesion, albeit often ironic and ambivalent, in the confusion of formless matter that often surrounds them. The moose triumphs temporarily on a rubbish heap of accumulated bits and pieces. In *The sooner you get away from here the better*, the little toy car seems precariously poised on a crazy helter-skelter of decay. On the one hand, the recognisable commodity objects provide a moment of relief from the effort to read so many unidentifiable forms, but on the other they are not immune from their surroundings. Despite the pre-eminence they are each given by the composition, both the moose and the car seem vulnerable here, their ephemerality underlined by the formlessness on the brink of which they teeter. These throwaway commodity objects are about to lapse into the uselessness and meaninglessness over which they are given temporary mastery, and it is this that gives them a certain pathos in Gall's work. The burst balloon seems emblematic here, emphasising these things' existence in time, and making literal the deflation of what was once the bright, shiny, object of desire. In a world where children are aggressively targeted as consumers, the logic of the commodity, with its dynamics of novelty, disposability and obsolescence, intersects poignantly with the workings of childhood imagination. These are the tensions that Gall's paintings show us.

But it would be misleading to suggest that these works are pessimistic about what objects mean to us, even in their cheapest commodity form. Gall keeps alive the sense of joyous profusion in the energy these works give off. Commodities, however pointless or fatuous, are celebrated, not just for their pure aesthetic qualities (though these are emphasised by the illusionistic brilliance with which the bright colours and extraordinary textures are rendered) but for their imaginative potential, their ability to populate fantastical landscapes and bring alive imaginary worlds. And this insight from childhood co-exists with the cynicism and suspicion that can't quite keep it down; there's another kind of disavowal going on here.

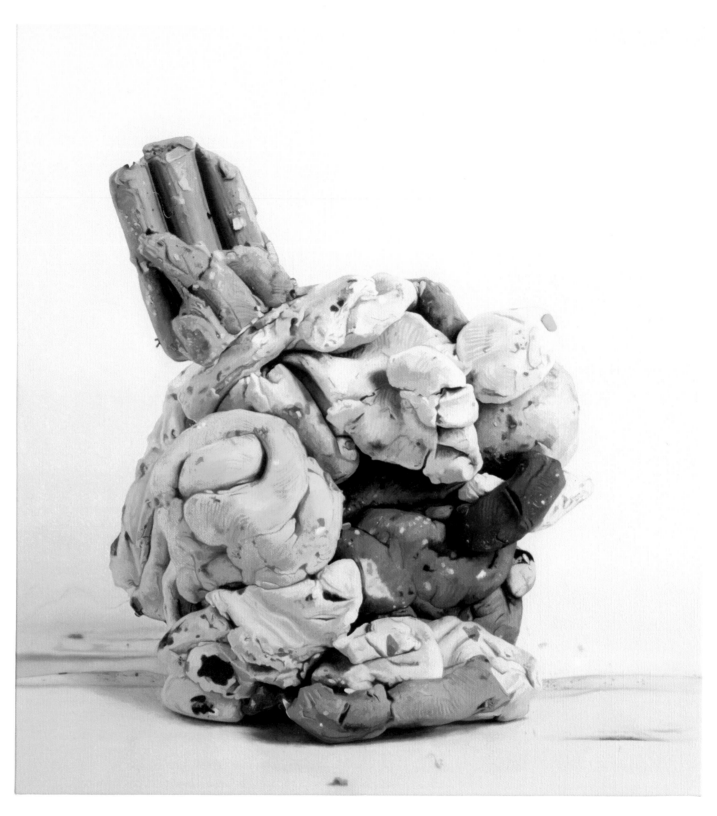

Down and out
2004, oil on linen, 66 x 61 cm

johanna malt **VISIBILITY AND THE SEEN**

ENTROPY As I suggested with regard to the role of commodities, there are tensions in Gall's work between matter and form. On the level of the things represented, one might say that formless stuff aspires to form in these paintings, and objects have their forms assailed by the association with formlessness. Hence the precariousness of form's brief and ironic triumphs within the images Gall creates. It is also significant that certain textures of matter preponderate in the constructions he makes and then depicts. Plasticine is everywhere, whether rolled into almost perfect spherical forms, modelled into landscapes, left in its original extruded strips or agglomerated in a shapeless mass. Similar materials such as glue and paint also appear, their significance here being partly due to their existence between liquid and solid. Plasticine, unlike other modelling materials such as clay or plaster, never hardens irreversibly into a particular form; heat it up and it melts into formlessness once more. The paintings that themselves depict blobs of paint seem to interrogate their own medium along similar lines: can paint ever really take form?

Art seems to have fixated on entropy since the 1960s, from Arte Povera and Post-minimalism onwards. Going back to Krauss' article (first published in 1977), one might relate this fascination to the rise of the index. As the work of art increasingly refuses to distinguish itself from other categories of objects, and indeed from itself as pure object, it increasingly becomes an index of its own material composition. And once artists begin to foreground the instability and impermanence of that composition, for example by using ephemeral materials that build a limited life span into the work, the work becomes an index of entropy itself. What we are invited to observe when viewing it is the work's real-time participation in a universal movement towards disorder and dispersal. It becomes an equation of pure facticity plus time.

Gall's paintings address entropy too, as we have seen, but they offer an interesting counterpoint to its treatment in much contemporary art, a treatment which often borders on the fetishistic. With their photo-realist technique, these works don't explore entropy by foregrounding their own materiality — quite the opposite in fact. They examine it in their content while refusing it in their form. But this is not a retreat into some notion of the painting as immaterial image; nor could it be, in the context in which Gall works. It is rather that the distance Gall's technique (including the mediating intervention of photography) creates from the real it depicts works against any fetishisation of entropy, choosing instead to keep it in play in a kind of dialectic between the physical and imaginary elements of the work. In opposing the potential chaos of matter that his models suggest, with formal unity and an appearance of detached impartiality, Gall invites us to explore yet more tipping points: between image-perception and object-perception, between the object's material transience and the persistence of the mental image, and, as we shall see, between the posture of transparency and the recalcitrant 'invisibility' of the real.

95

SURFACE The photo-realist technique has many implications in Gall's work. To some extent it functions in the same way as illusionist or at least realist techniques function in much Surrealist painting. In such works, mimesis (along with perspective, as I have already argued) is an ordering principle in a mode of painting that might otherwise end up equating fantasy with total abstraction. For the Surrealists, especially those who were at any point close to the group's founder and unofficial 'leader' André Breton, total abstraction posed a danger, since the movement always insisted on a meaningful distinction between 'surreal' and 'unreal', the former aspiring to some kind of dialectical synthesis between external reality and the interior life of the mind. The recognisable real may be reconfigured, rendered strange, juxtaposed with the unreal and the fantastical, but it *is* represented in such works, and it is this stable ground of representation that, for the Surrealists, anchors the work in real life. In Gall's painting too, mimesis is a structuring principle, a form of order in the face of their potentially chaotic content.

And the technique has other resonances, especially in the composition and the rather classical use of light and shadow. In paintings such as *Hidden by the calamities* and *Materials for reasoning*, these have the effect of ennobling the objects depicted by association with the great traditions of still life painting. And painting itself is ennobled by these resonances too, and only partly ironically, for as we have seen, irony and playfulness always threaten but never quite undermine the seriousness of purpose of the works.

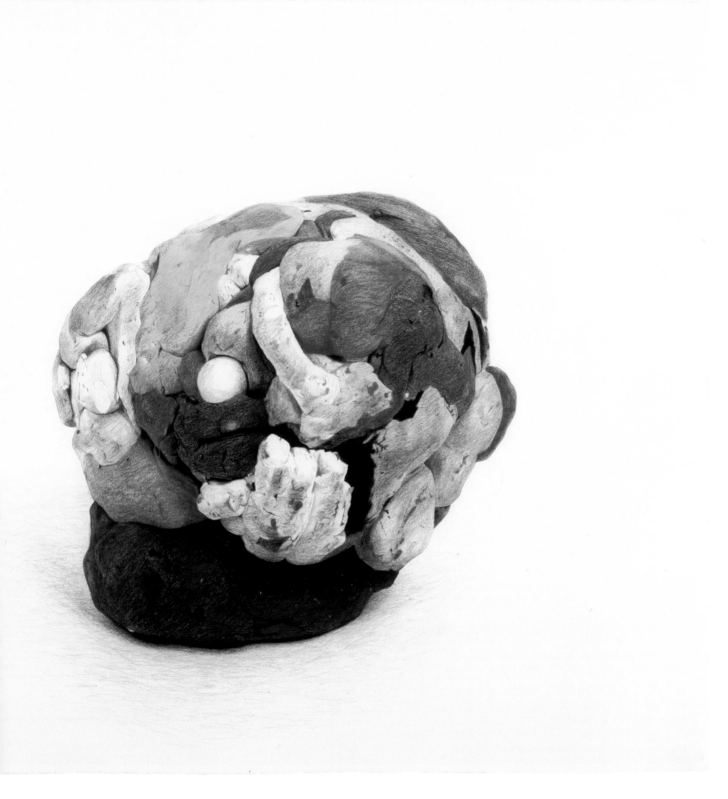

Bad brains
2005, coloured pencil on paper, 75 x 87 cm

Hidden by the calamities
2005, oil on linen, 122 x 147 cm

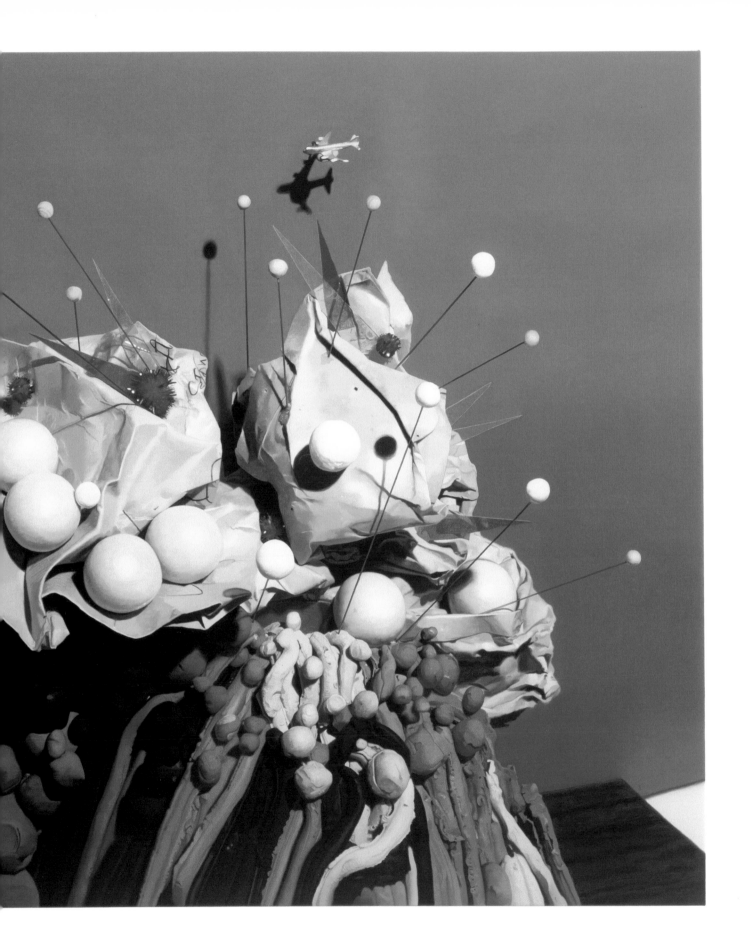

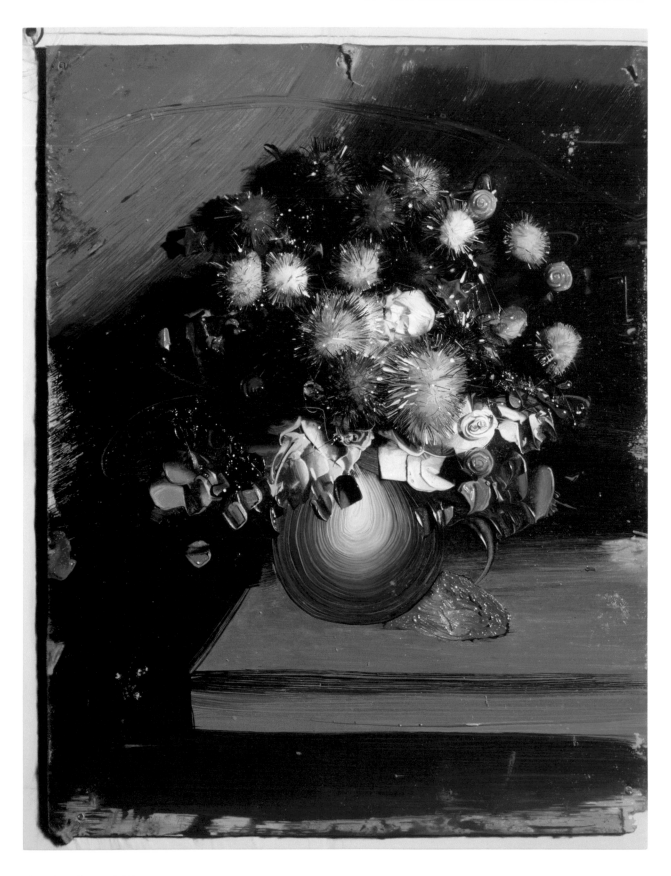

Greetings from Well Street
2006, oil on linen, 102 x 81.5 cm

johanna malt **VISIBILITY AND THE SEEN**

For all their apparent explicitness, the theme of concealment is perhaps one of the strongest threads running through Gall's works. Most obviously, it appears in the process of construction of the models with which he begins. The taping of the clusters of balls used so frequently is an act of masking, hiding and fixing the object all at once. On the one hand, this concealment immobilises the balls, both literally, and by embedding them in a very specific formal relation from which our interpretation of them can't escape. But on the other hand, the masking is also a construction of something else; the creation of a mystery, a secret life for the object in the domain of fantasy. In some works, as we have seen, it borders on an act of personification. I would argue that the surface of the object, represented by the tape, is also a kind of second skin, a membrane that contains and imposes form, sometimes following the surface beneath it, moulding to it, but sometimes distorting and blurring it. This 'skin' is a surface of indeterminacy, a plane where recognition and fantasy intersect, where the contradictions of explicitness and veiling converge. The perfect and impenetrable painted surface seals the object off behind a distance of mimesis which the photo-realist technique's code of transparency and accuracy resists, telling us we're seeing everything. Everything is on view here, but at the same time there is nothing to see, for the process of representing (and therefore revealing) is always also a concealment, the drawing of a veil. And as I suggested earlier, the depiction of paint as subject matter is no coincidence. These are paintings about the limits of painting, and their own immateriality expresses the paradox of what the painting does to the world by representing it, by laying itself over the real like another skin.

What's so compelling in these paintings is that they all contain fault lines or tipping points of various kinds, sometimes visible and sometimes unseen. These are the moments when the paintings ask us particular questions, the points at which two modes, two readings, two contradictory beliefs come into contact without cancelling each other out. *Greetings from Well Street* is an instance of the visible line, and in this case it's a rather literal one. The work is a painting of a kitschy amateurish still-life painting, a found object which Gall modified and then painted from a photograph. The edge of the found painting is depicted as the frame of a *mise en abîme*, the representation of a representation that makes literal and visible the layers of mediation which Gall's working practices always interpose between the object and the painting of it. *Materials for reasoning* offers the table edge, and the torn edge of the paper as a kind of seam between two modes of interpretation.

Other works use different tactics to provoke similar responses. The effects of focus created by the photographic lens and then incorporated into the painting raise our awareness of something intervening between us and the object, despite (and in fact, in this case *because* of) the painting's posture of accuracy and explicitness. The out-of-focus areas in the painting become a kind of metaphor for the limits of seeing. In one of the most recent works, *God of thunder*, something peculiar happens in the top half of the painting, where the familiar perspectival mode that dominates the lower part threatens to give way to two-dimensional abstraction. In some parts of the painting, the blue background reads unproblematically as a slightly crumpled sheet of paper pinned to the wall behind the paper model of a dog-like creature. But in other areas, when the painting is seen 'in the flesh', the eye starts to read against perspective and the blue and shades of white become abstract flat planes of colour. These are moments of real optical and interpretative tension, when the painting seems about to liberate itself from the mimetic 'enslavement' to the real object it usually dangles ironically in front of the viewer.

Which brings us back, finally, to the question of where fantasy is in these works. On one level, painting itself seems evacuated of everything except mimesis here. Imagination and fantasy are outside and beyond it, in the way in which we interact with objects in the real, and in the construction of the extraordinary models and worlds Gall makes in order to paint them. On the surface at least, painting seems secondary to these acts of creative imagination. But what Gall's work shows us is that painting as an act of 'perfect' representation is not reproduction, does not seal off the object behind a neutral and distancing window of transparency. Rather, it throws a kind of skin over the world: contiguous with it and at the same time not of a piece with it, a surface on which our own fantasy projections and beliefs about the world can crystallise. And the fault lines in this surface are like crevices where the imagination can lodge itself. They are the real spaces of fantasy here.

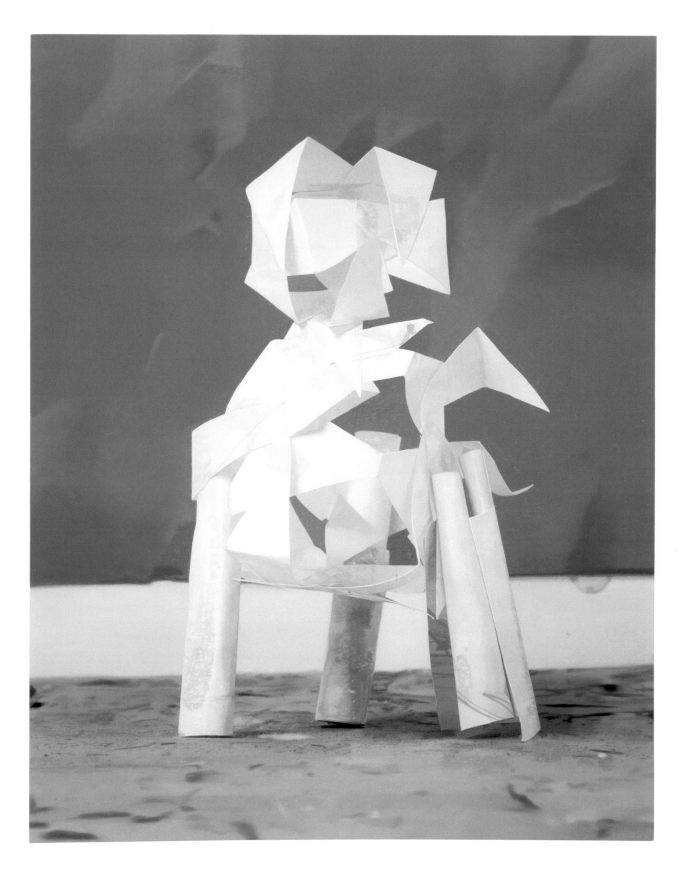

God of thunder
2006, oil on linen, 160 x 127 cm

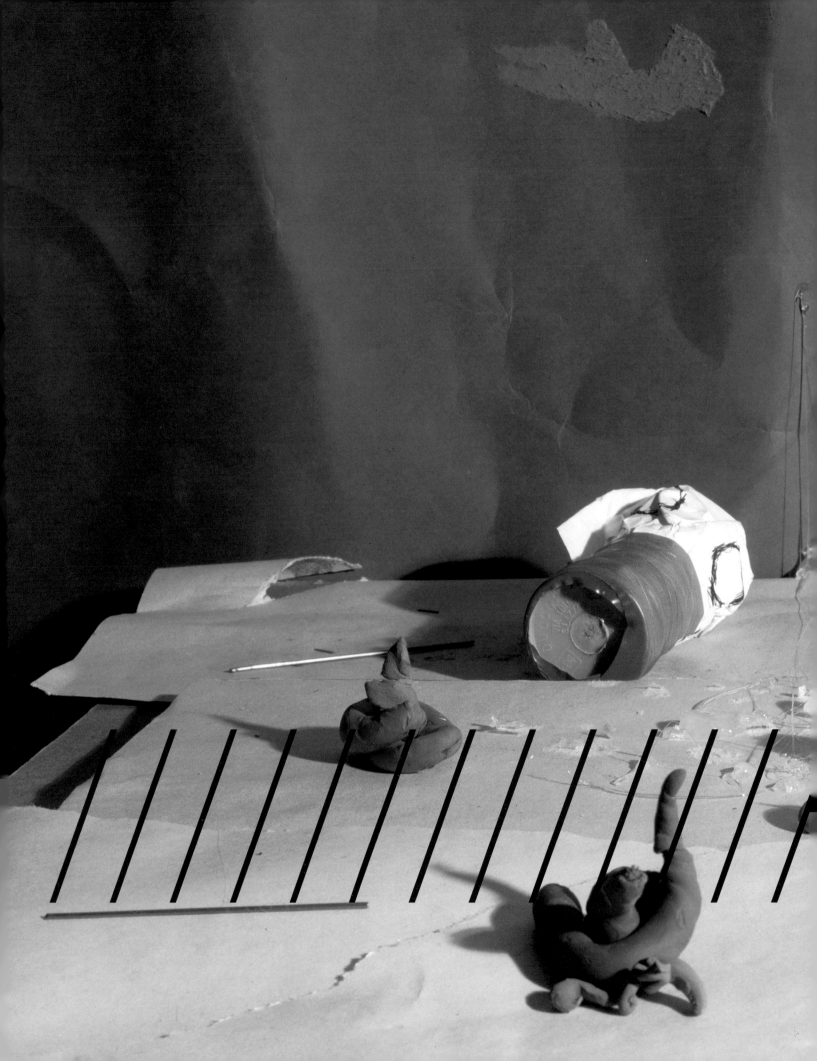

///////// TYPE

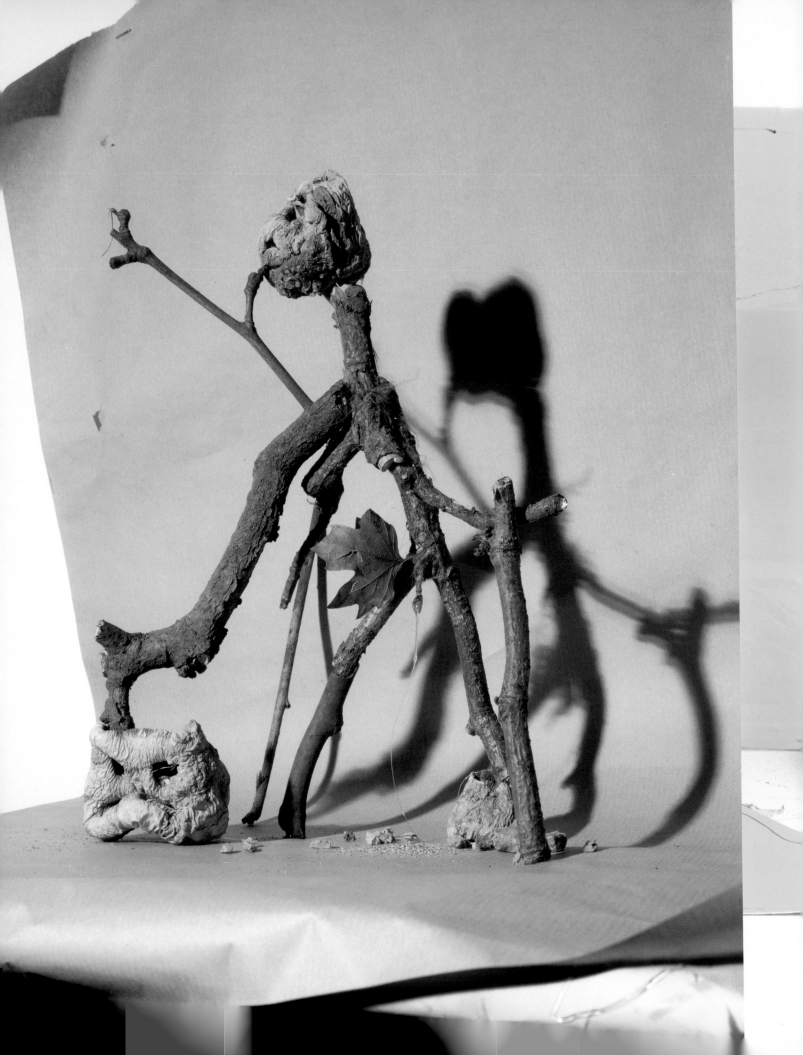

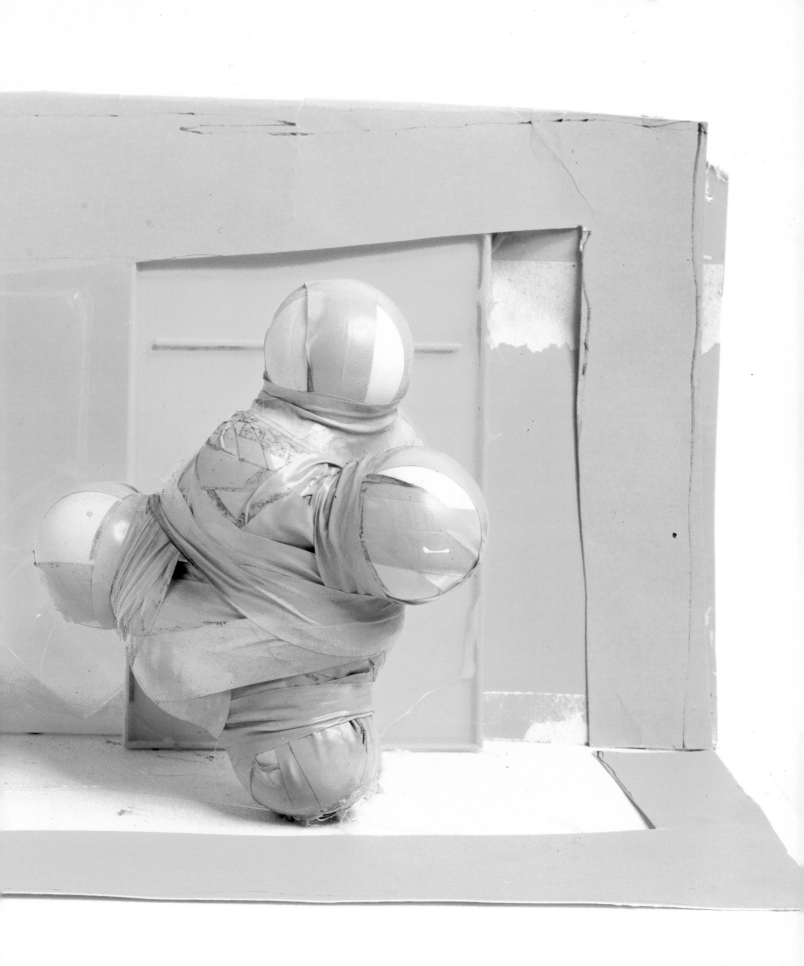

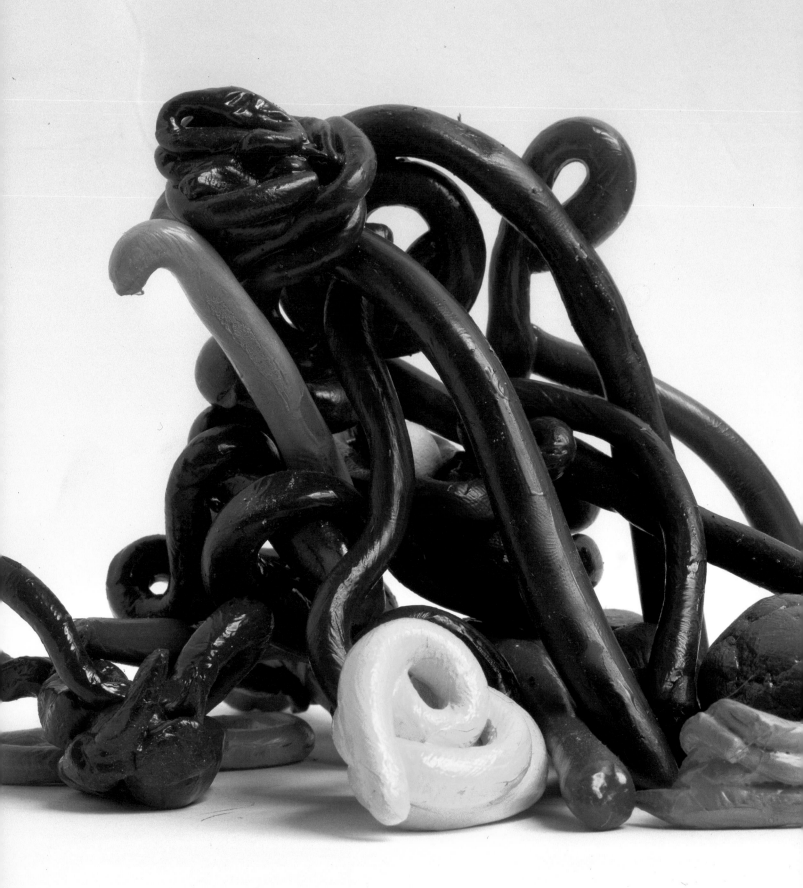

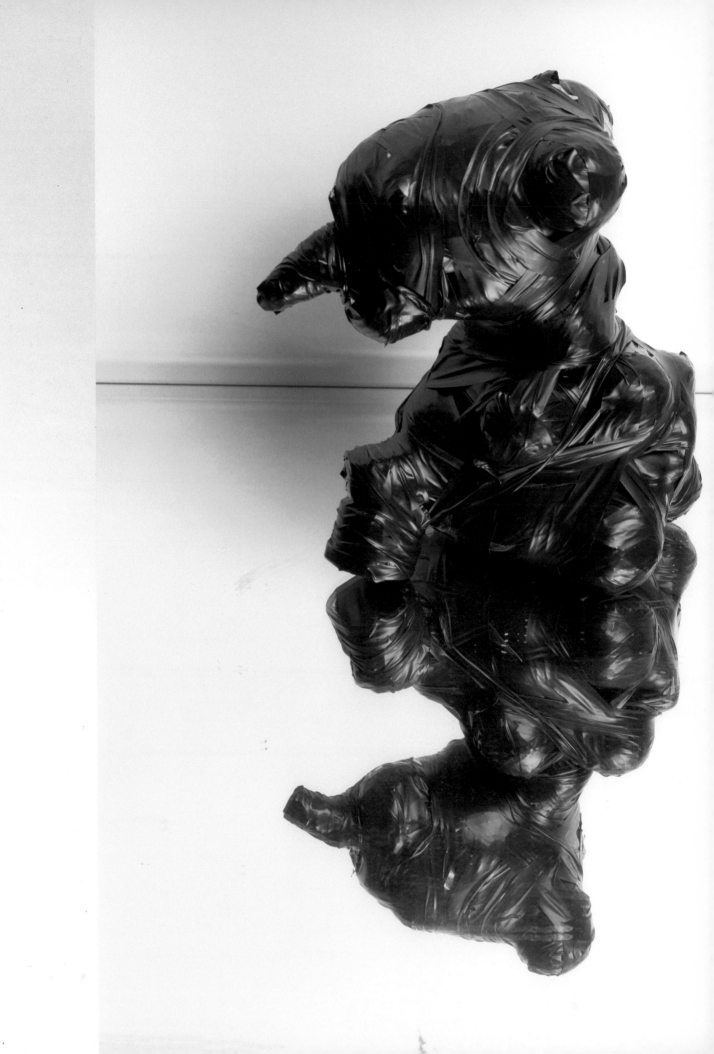

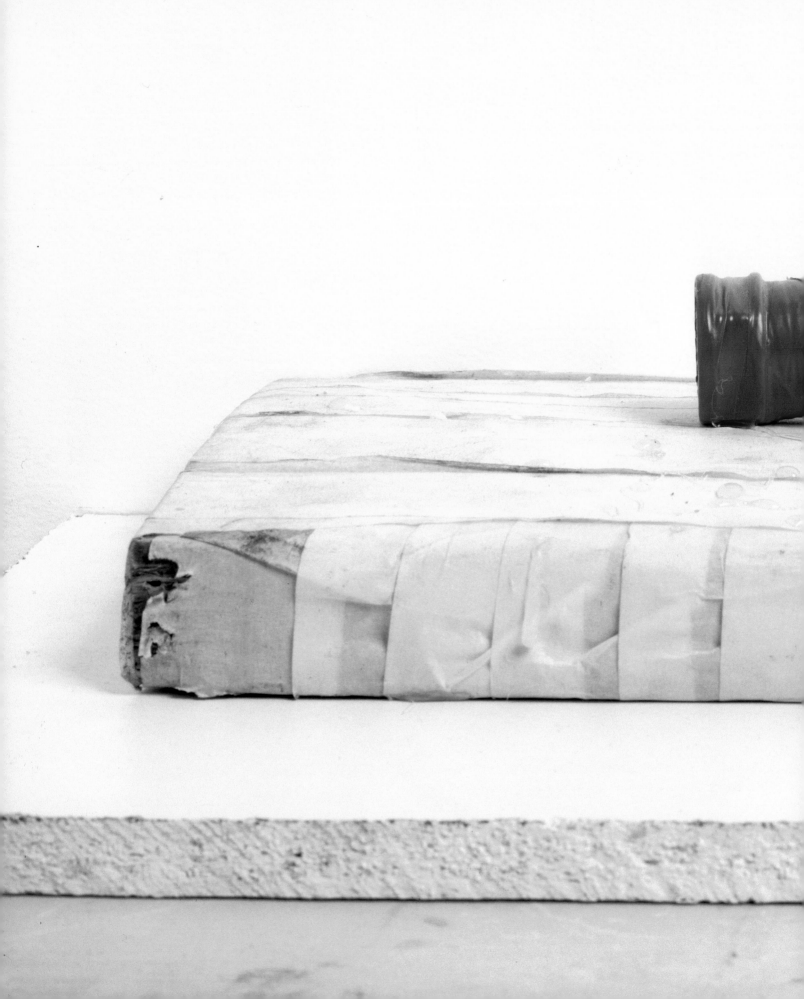

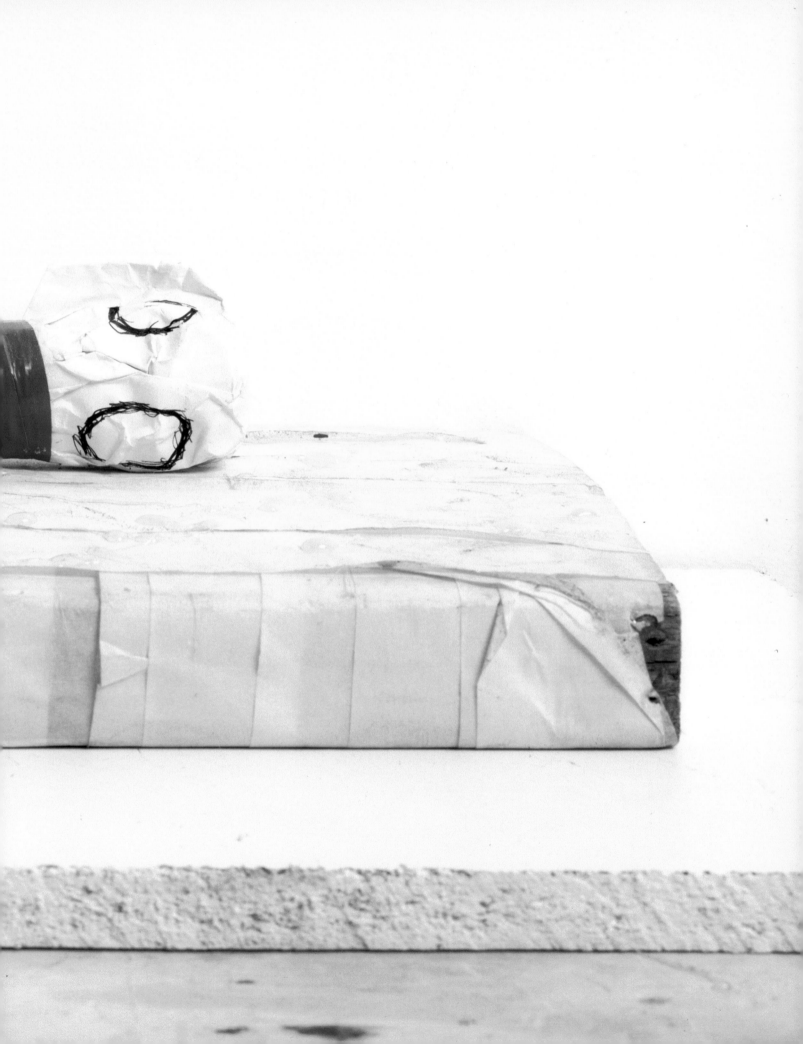

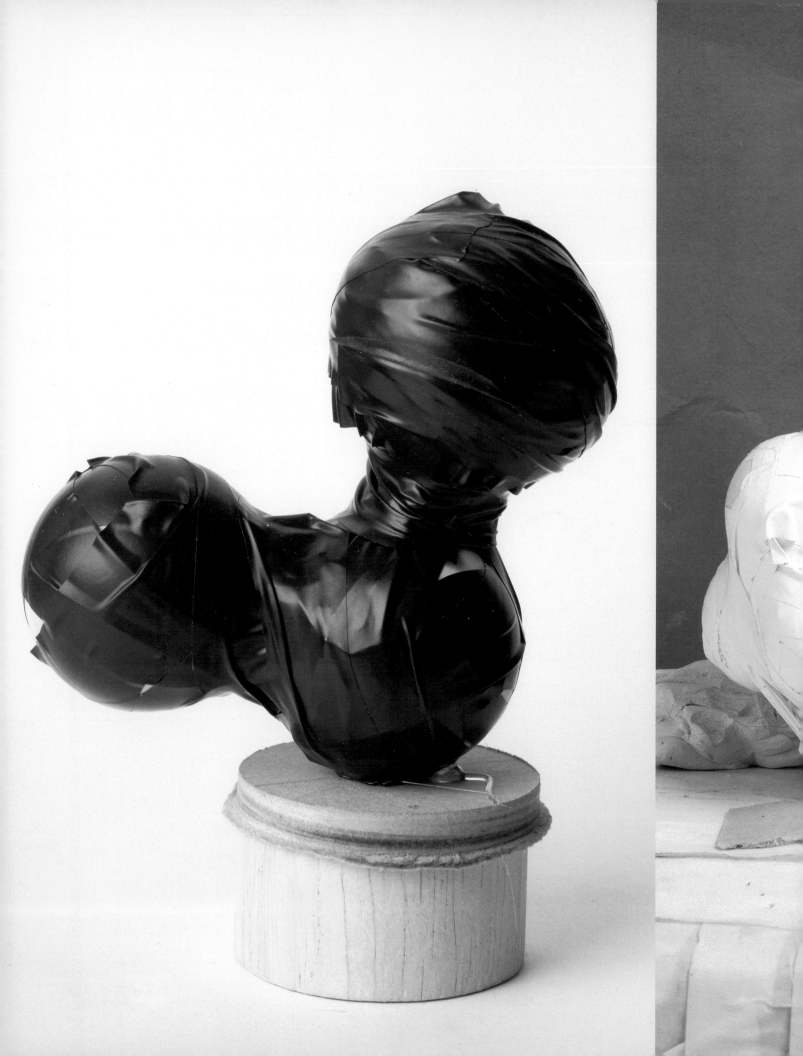

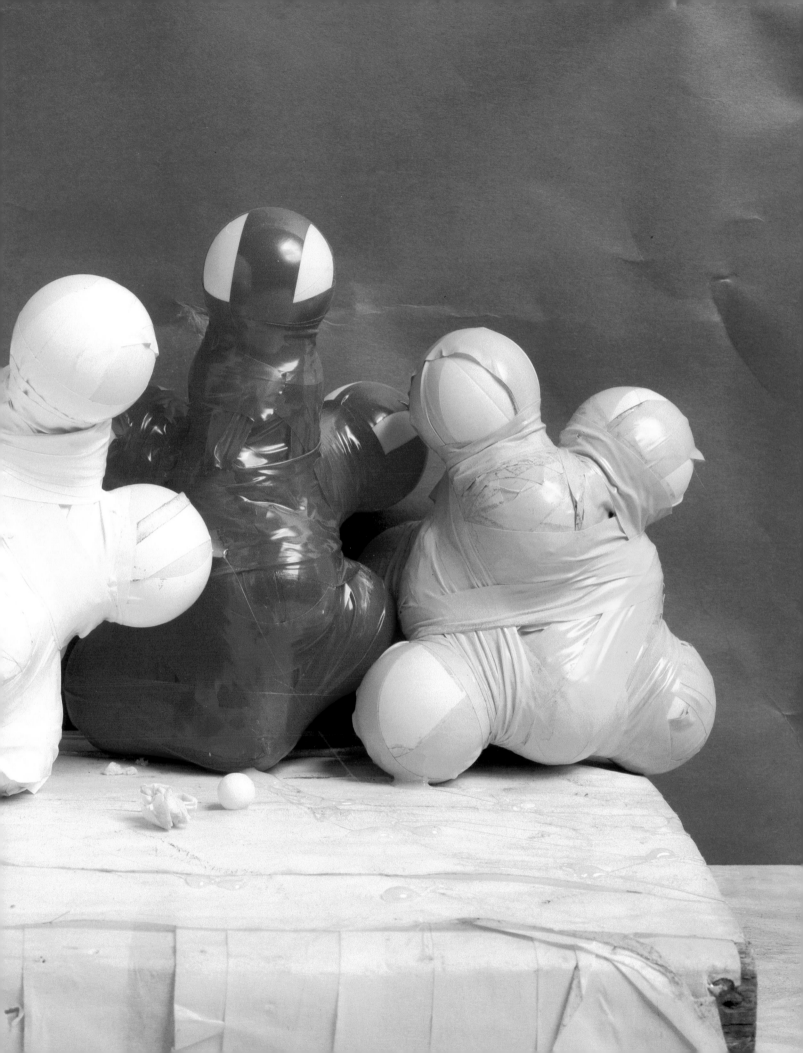

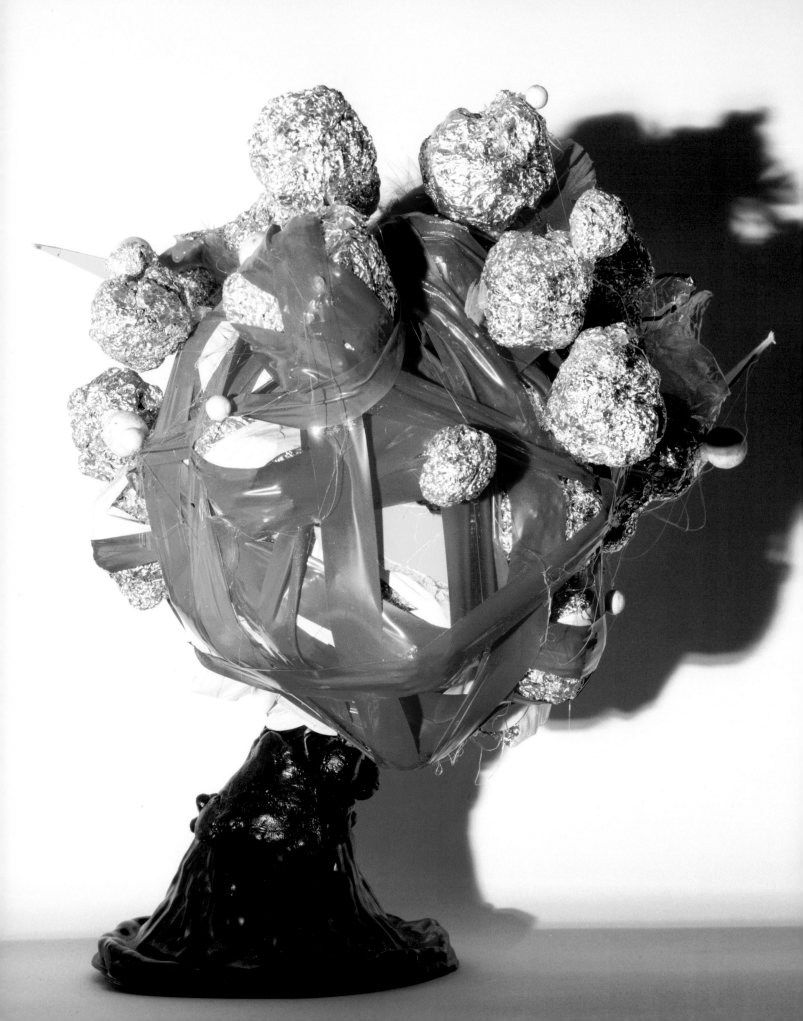

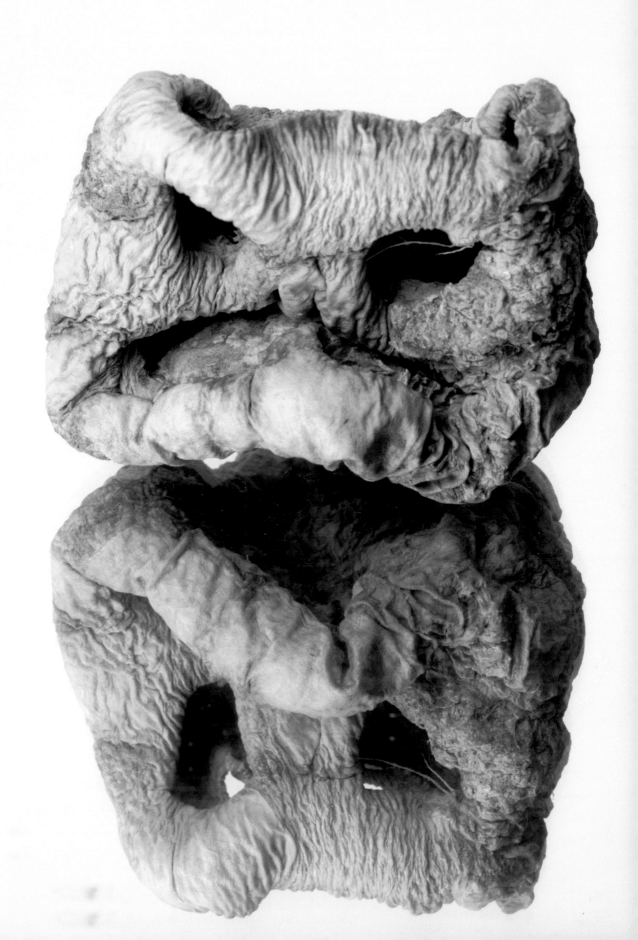

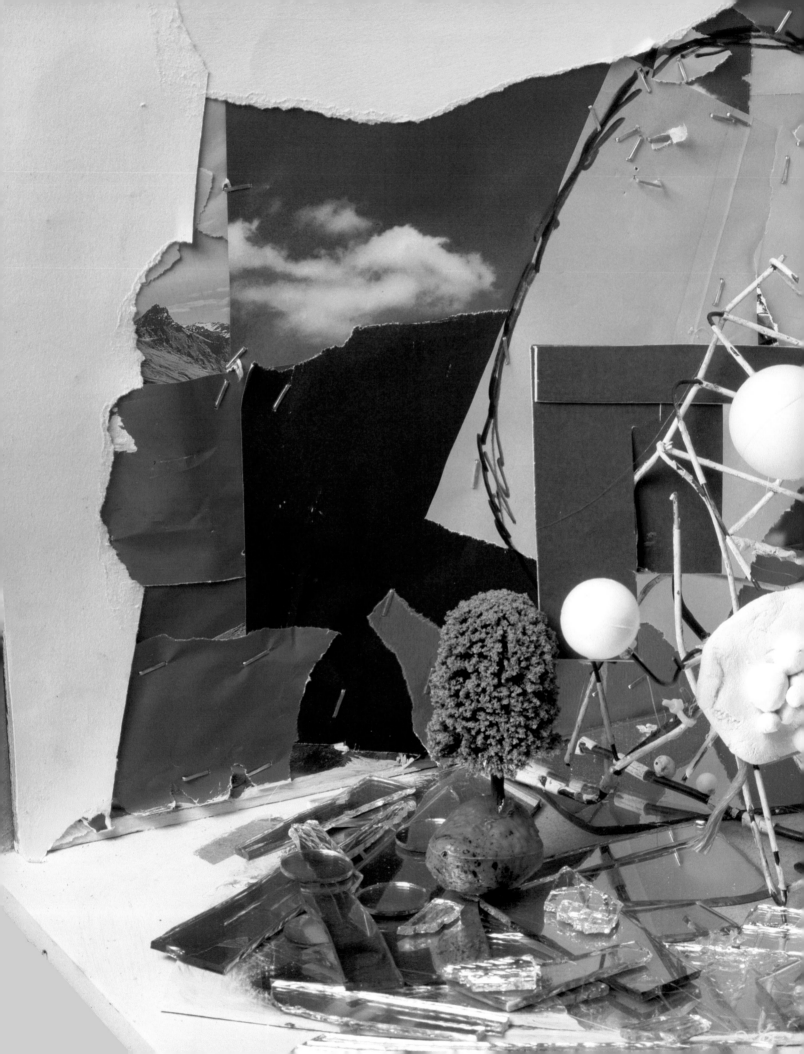

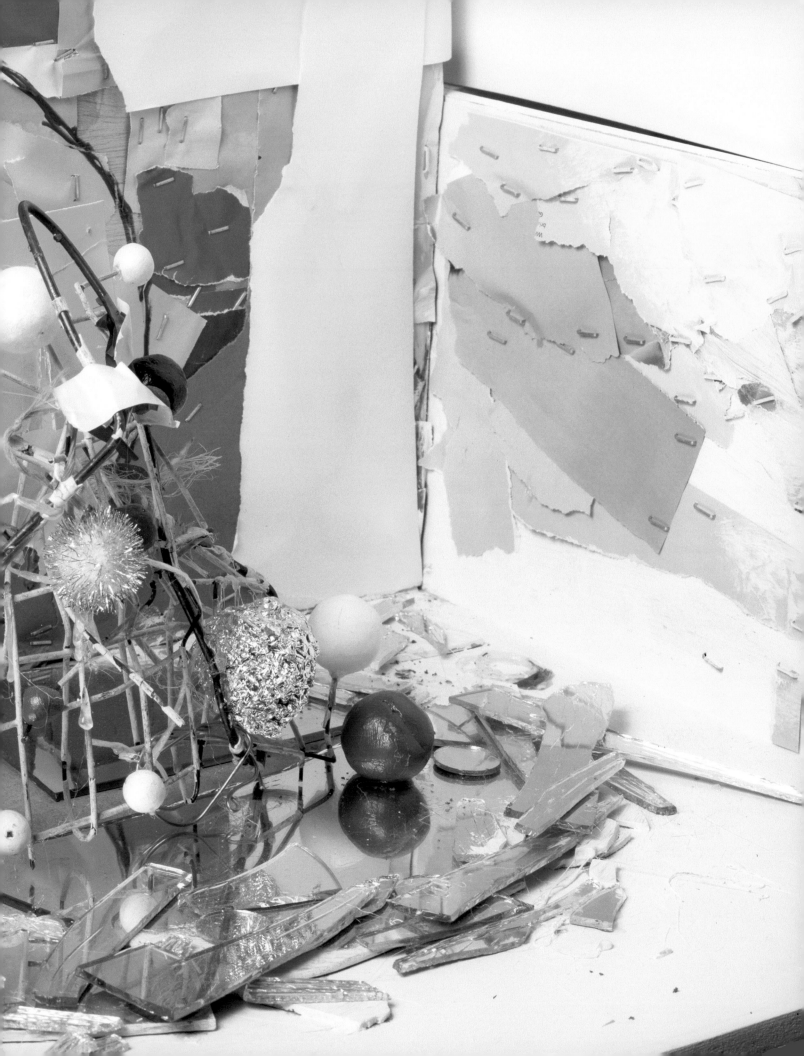

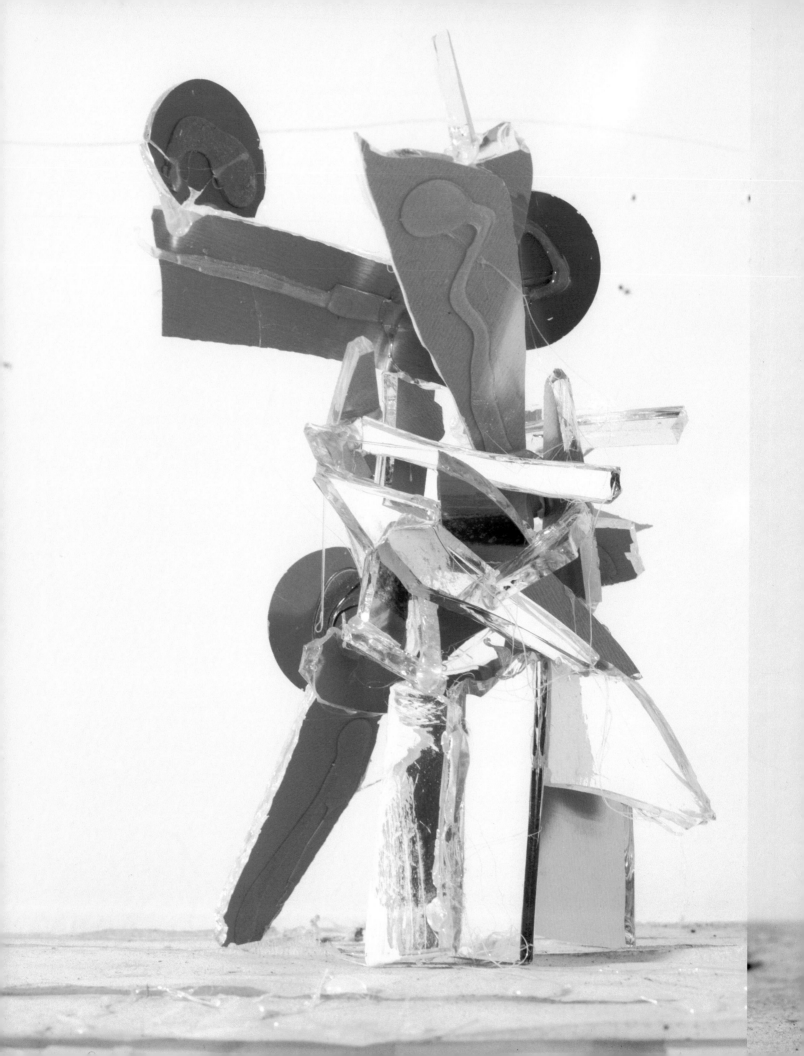

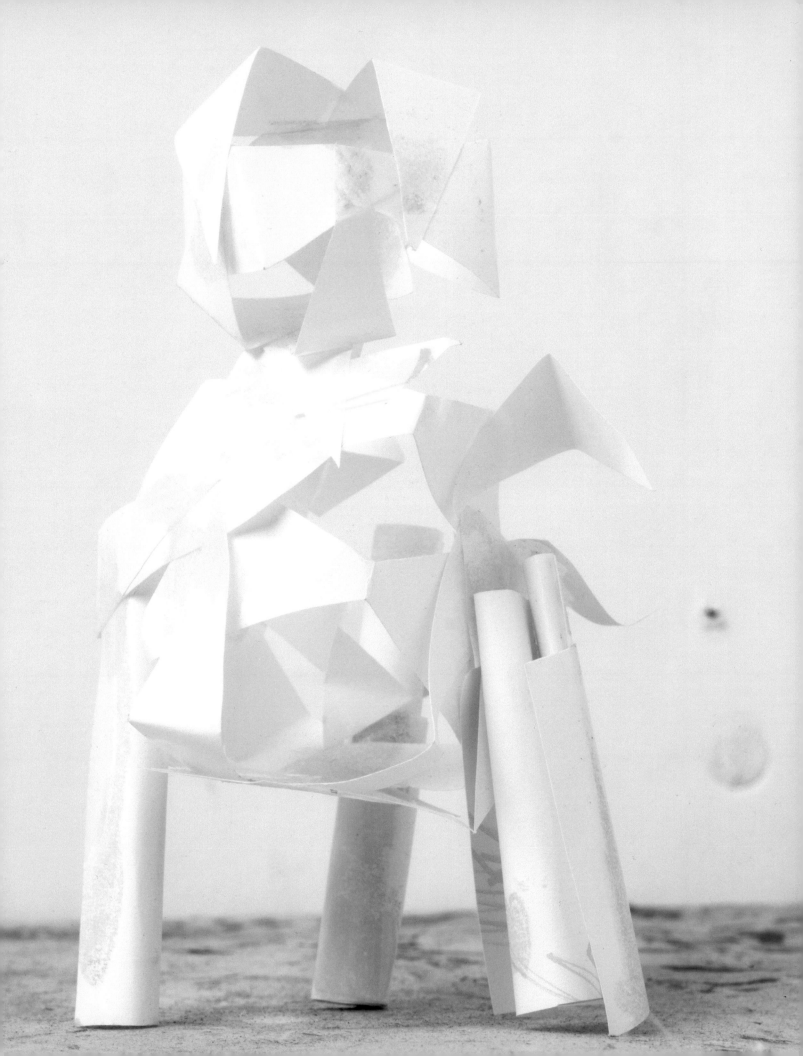

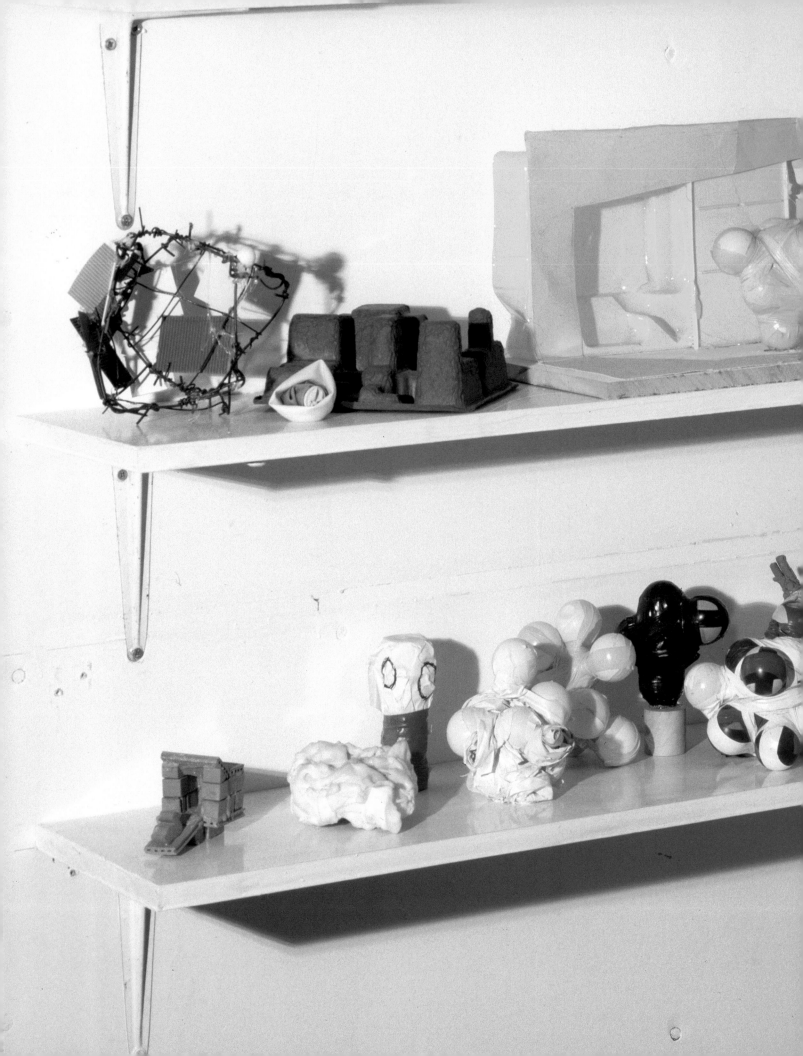

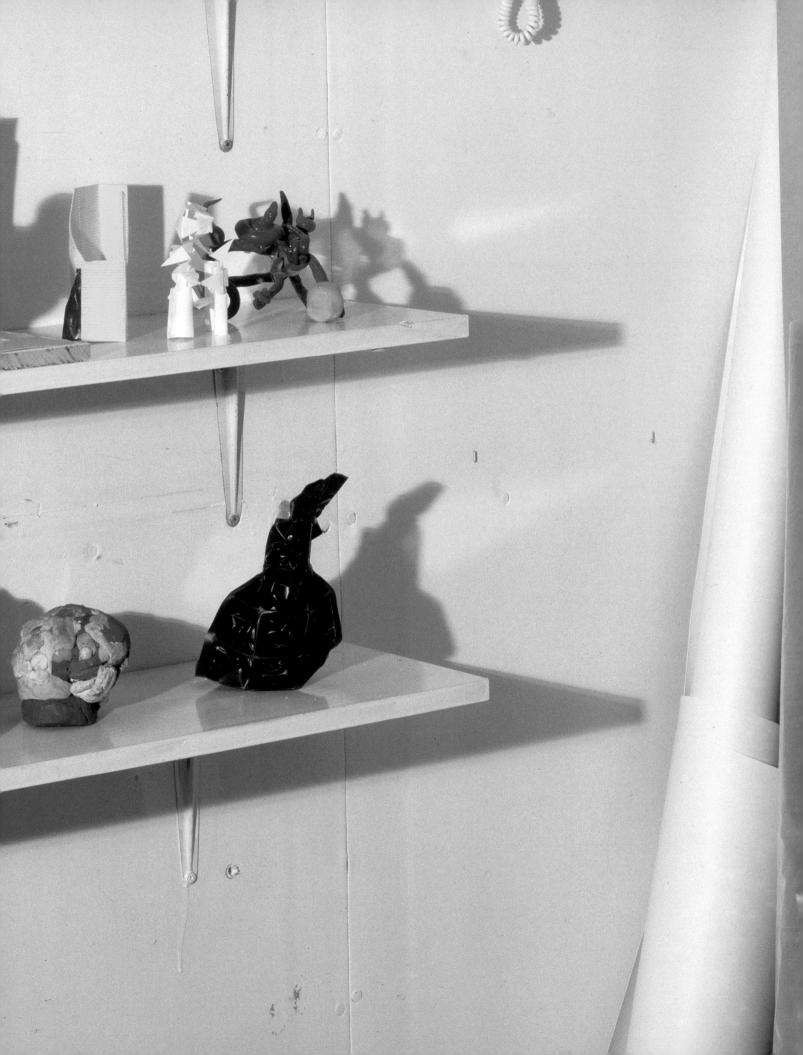

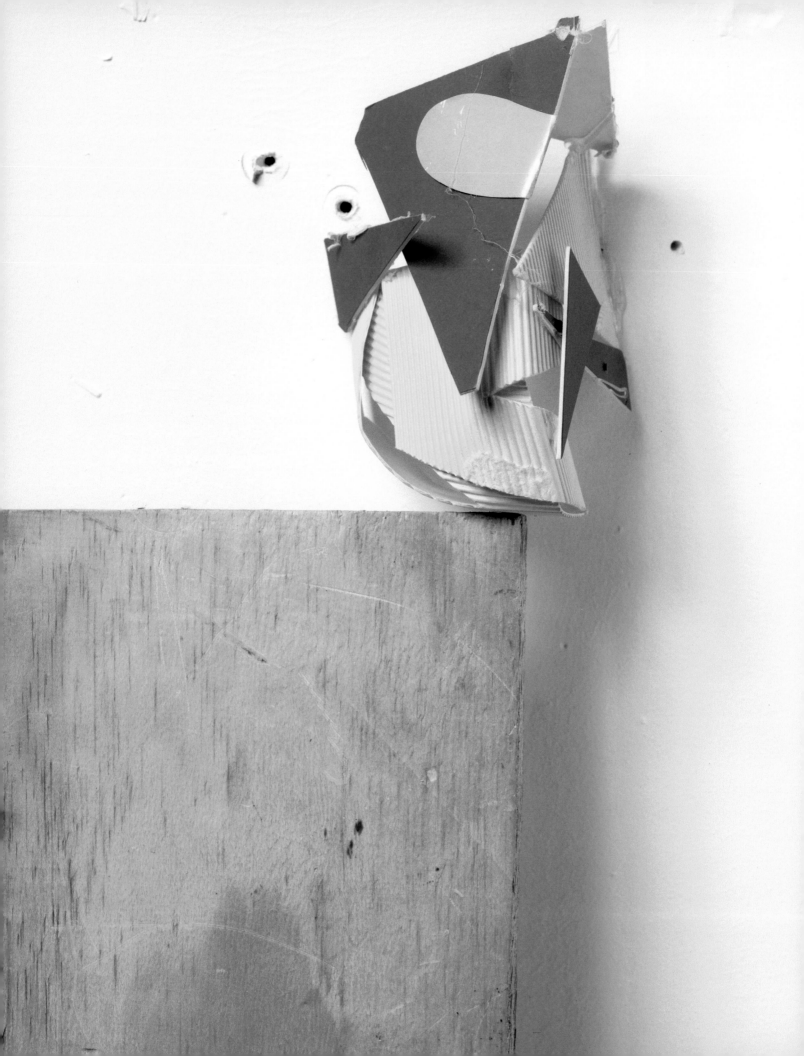

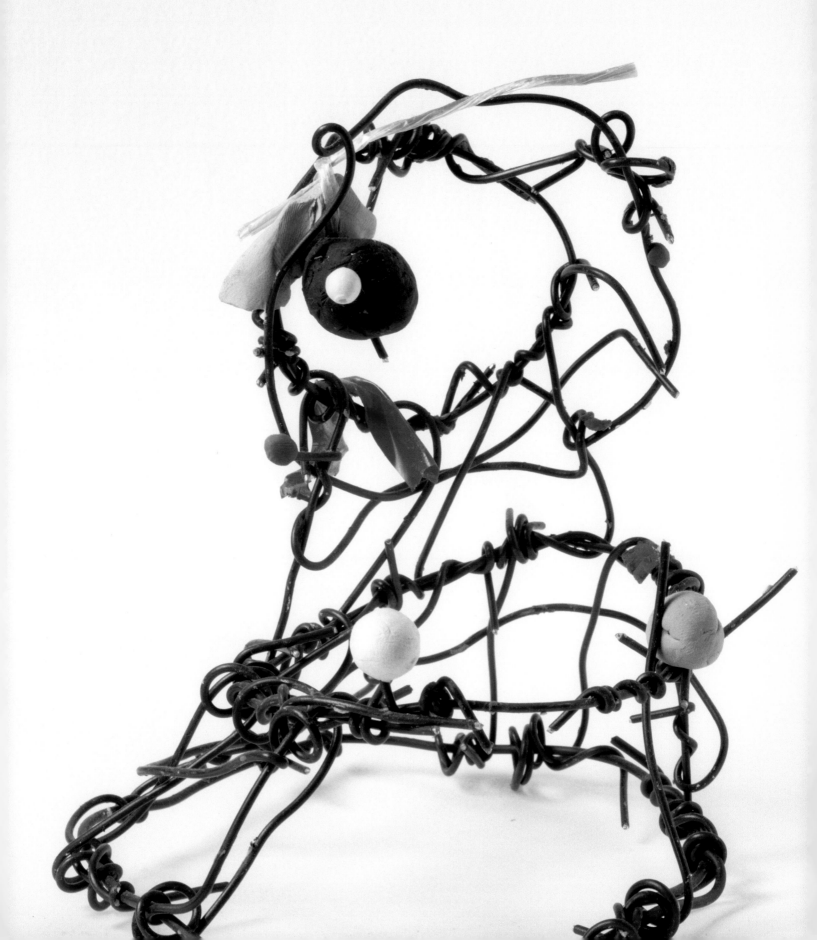

charles darwent//

ON
THE
/GRID

LEFT
Rollercoaster, Aberdeen beach esplande,
1988, source photograph

RIGHT
Northfield radio tower, Aberdeen,
1988, source photograph

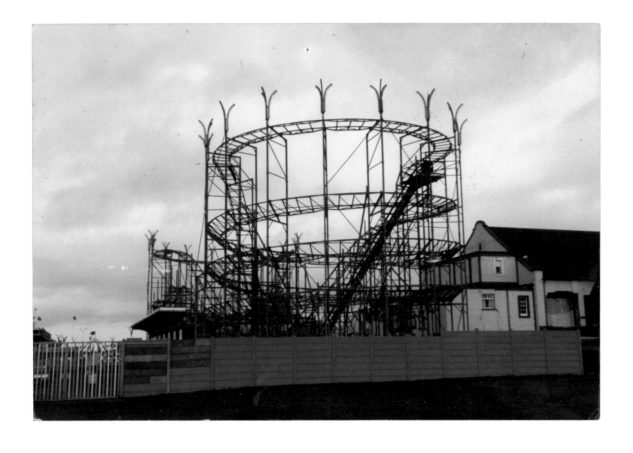

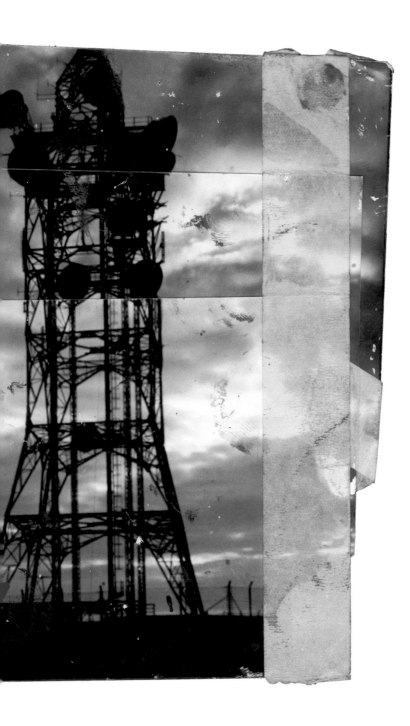

When I first met Neil Gall in January 2001, he had just done an unusual thing. Like many young painters — Gall was then 33 — he had found himself working in the style of an established artist; in his case, Gerhard Richter. This was reasonable enough. Richter's German brand of Pop Art has always been more intellectually satisfying than its British or American counterparts, and has made him rich and famous. Like their ancestors, successful modern painters spawn followers and schools. There was no shame in Gall's being a Richterite, and toeing the German line hadn't harmed his cause. He'd done well on his post-graduate course at the Slade and, after graduation, went on to the British School in Rome.

But Gall was unhappy. Following another artist obviously imposes a discipline of its own, but for him the rules had become sterile. If he had stuck with it, Gall would no doubt have found an authentic post-Richterite voice; but, by 1996, he wasn't sure that he wanted to. He might one day end up painting like Richter — in some ways he has — but he wanted to get there under his own steam. And so Gall did something rare for a young London artist. Packing up his paints, he took the coach back to his native Aberdeen and started teaching at the art school, Gray's, where he had been an undergraduate. For four long years, Gall slogged up and down the motorway on National Express, staying with his parents in his childhood bedroom.

It's tempting to read this journey home as a metaphor for an artistic starting-over, and that's how I chose (and choose) to see it. Scottish art schools have a reputation for teaching their students the three R's of painting, the most subversively un-London of these being life drawing. It was possible to become a Richterite without knowing how to draw, but then Gall did know how to draw. It was as if, having learned to walk, he had wilfully spent his career electing not to. The question that faced him in 1996 was how to find his own voice, taking into account his personal history and skills.

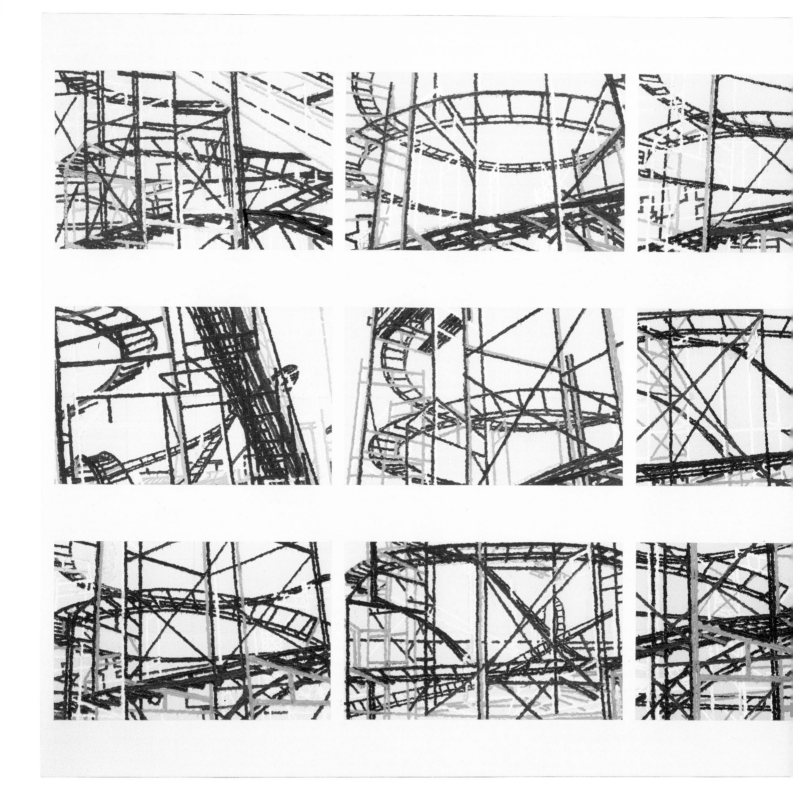

Loop
1999, oil on canvas, 157 x 183 cm

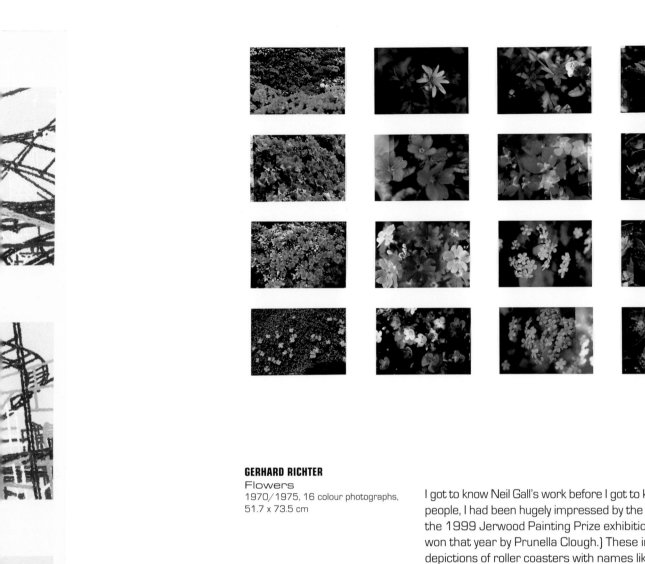

GERHARD RICHTER
Flowers
1970/1975, 16 colour photographs,
51.7 x 73.5 cm

I got to know Neil Gall's work before I got to know Neil Gall. Like many people, I had been hugely impressed by the paintings he showed at the 1999 Jerwood Painting Prize exhibition. (The prize itself was won that year by Prunella Clough.) These included a number of depictions of roller coasters with names like *Mousetrap*, a subject he had also painted repeatedly as an undergraduate at Gray's.

The subject was obviously evocative, touched with something of the post-industrial anomie of Ed Ruscha's gas station paintings or the photographs of Bernd and Hilla Becher. But the odd thing about Gall's Aberdeen pictures was that it wasn't really their subject that struck you, or at least not at first. What was curious was the way that works like the nine-part *Loop* evolved internally from what looked like an abstract pattern. No one part of *Loop* gave any sense of its overall structure, and this, too, seemed autobiographical. Whatever else it was about, *Loop* was about piecing together disparate things in order to find an answer.

This strategy had been used by Richter himself in his *Atlas* project — an encyclopaedic work, now 40 years in the making, built up of an ever-growing number of images arranged in an ever-shifting grid. (At last count, there were more than 4,000 of these fractals.) Richter likes to compare the work with a book: "In my picture atlas", he says, "I get a handle on the flood of images by creating an order for them. Then the idea of individual images ceases to exist."[1] Without wading too far into the quicksands of critical theory, *Atlas* illustrates Walter Benjamin's idea of the *Jetztzeit*: a now-time in which any one thing is contingent upon everything that precedes or follows it.

1_Buchloh, Benjamin HD, "Gerhard Richters Atlas: Das Archiv der Anomie", *Gerhard Richter*, vol. 2, Bonn: Kunst und Austellungshalle der Bundesrepublik Deutschland, 1993.

RIGHT
VLADIMIR TATLIN
Monument to the Third
International
1919

OPPOSITE
Mousetrap
1999, oil on canvas, 162 x 183 cm

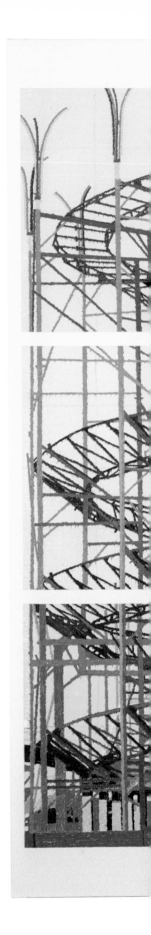

If *Loop* played with the same ideas as Richter, though, it was less as a declaration of love than of independence. The younger Gall's work may have found a single answer in the many, but it had done so in a profoundly un-Richterish way.

Like the German, Gall clearly saw himself as modern, or, more properly, as Modern. In compositional terms, *Loop* is built on that most Modernist of things, the grid. In fact, it is built on several grids — the checker-board of spaces separating the picture's nine parts, but also the grid-like structure of the switchback itself. Final year art theory students could have gone on for weeks about the picture's running together of reference and referents, but — while clearly understanding the concepts involved — *Loop* went out of its way to distance itself from critical wordplay. You sensed that Gall sided with Rosalind Krauss when she wrote: "It is not just the sheer number of careers that have been devoted to the exploration of the grid that is impressive [but] the fact that never could exploration have chosen less fertile ground." Like Krauss, *Mousetrap* seemed to see the grid as what is left when "art... turns its back on nature".[2]

2_Krauss, Rosalind, *The Originality of the Avant-Garde and Other Modernist Myths*, Cambridge MA: MIT Press, 1985.

Gall's lovely nine-parter may not have taken nature as its subject, but it did at least portray that subject naturalistically. For all that *Loop* looked like Tatlin's *Tower* re-imagined by Mondrian, its handling was emphatically old-fashioned: painterly, even. The roller coaster's pillars and struts were laid on in deep, anti-industrial impasto. As I wrote in a catalogue essay to a show Gall held in London in 2001, *Loop* and its fellows were meant to look freshly painted, their oils thick and wet. This was a new start, and it had to seem like one. Bound up in *Loop* was the story not just of Modernism but of Neil Gall as a painter; of his own relationship to the grid as a means of locating himself historically, but also, perhaps, as an instrument of his torture.

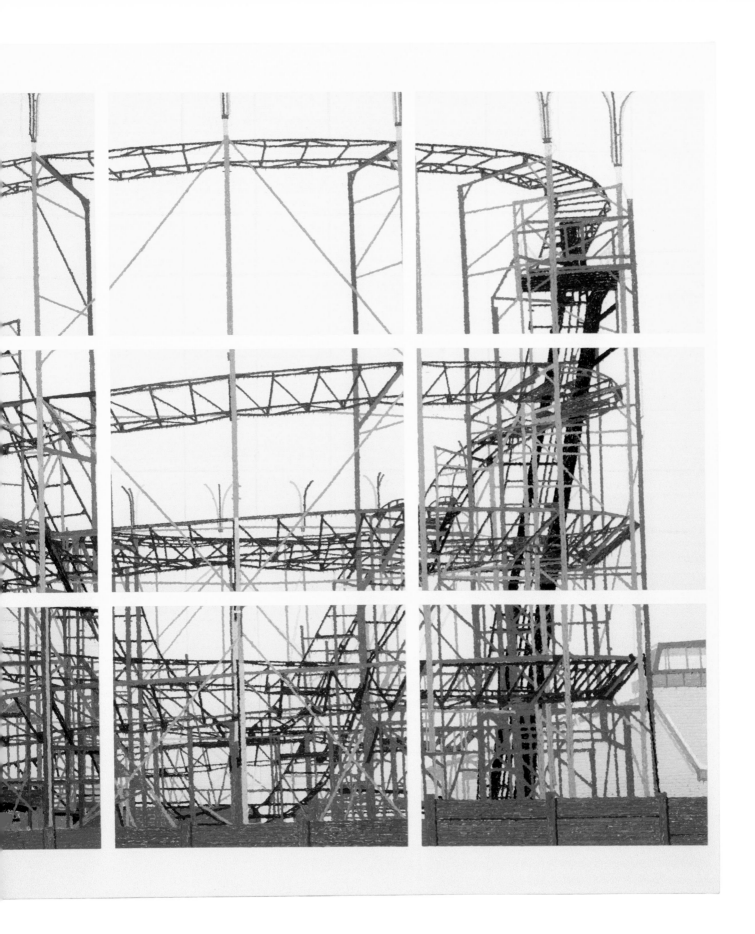

Way back when
2006, coloured pencil on paper,
66.8 x 84.5 cm

I'd like to jump forward for a moment now to the summer of
2006, when I visited Gall in his studio in east London. On the wall
was a large-scale colour pencil drawing, as yet unnamed, in his
latest series of work based on items of packaging found in the
street. Taken out of its context and scale — ennobled by the act of
being drawn — his blue moulded cardboard subject looked like an
idealised city. You found yourself thinking, unexpectedly, of
Bruegel's *Tower of Babel*.

This being Hackney and Gall's cardboard being inner-city rubbish,
you also found yourself thinking about urbanism and its place in
Modernist painting. Inevitably, this led back to Mondrian and, of
course, to the grid. But a half-finished canvas hanging next to
Gall's drawing also took you to the same place by a quite different
route. As with all his paintings, this one was being gridded up in
pencil, which seemed reasonable enough. Gall's current style is
what might broadly be called photorealist, and mathematical
accuracy is the watchword of photorealism. In any case, scaling-
up on the grid is as old as painting itself.

Gall's grid was also evidence of something else, though. Most
photo-realists work their way across the canvas square by
square, following no particular programme in terms of time.
By contrast, Gall paints complete areas in one go, his studio day
being dictated by the length of time it takes to do them. In his
own phrase, he works until he "gets to an edge, a clean join" —
a discrete area that strikes him as being self-contained. The
canvas-in-progress on his studio wall showed obvious signs of
this process, perhaps a third of its gridded surface being entirely
finished, the rest left absolutely blank.

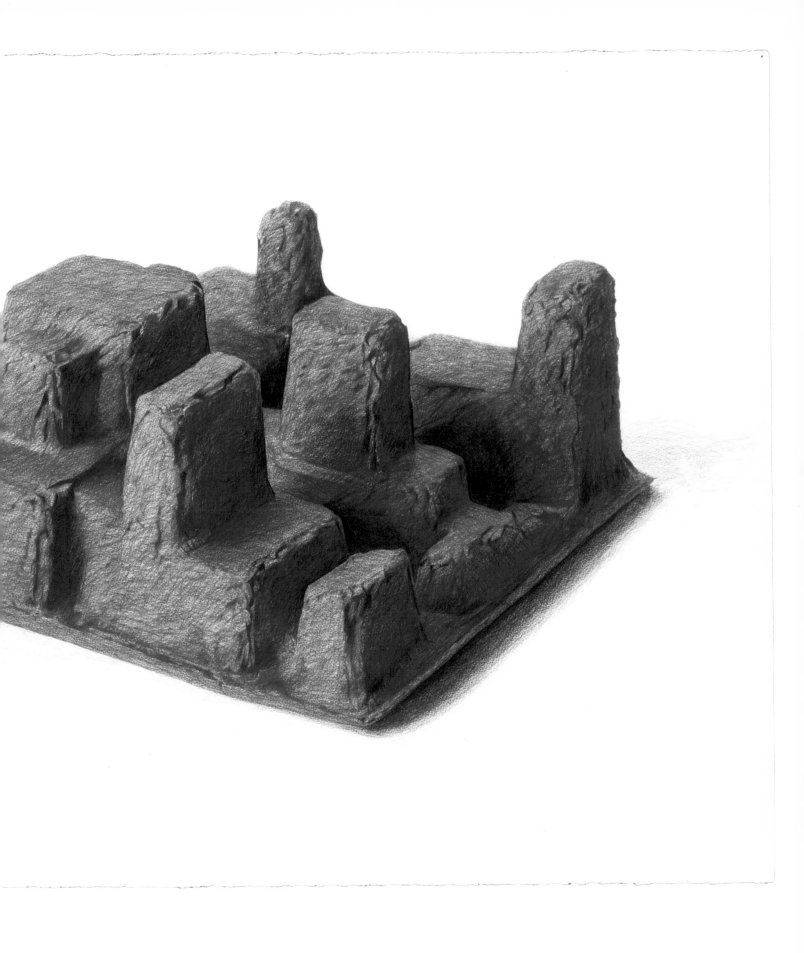

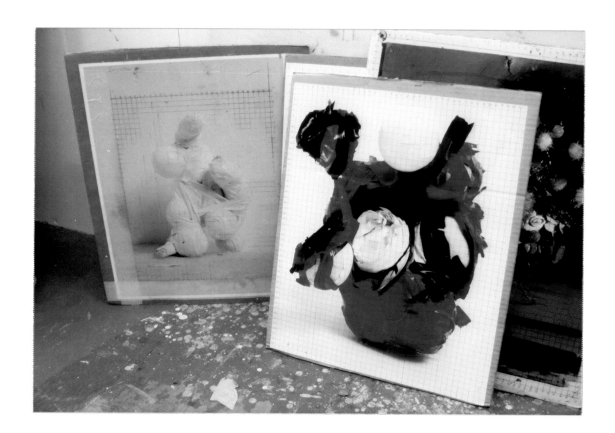

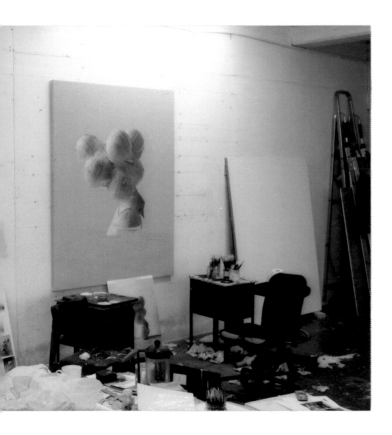

Put another way, Gall paints in *giornati* or day-work patches, in a method used by early Renaissance artists working in *fresco* on *intonaco*. (Presumably in recognition of this, one of his 2001 model paintings is called *Working Day*.) Like them, this means that he sometimes spends 20 straight hours in front of the canvas, starting at eight am and working on into the early hours of the next morning. At least one of Gall's paintings took five months to finish.

The question is, why? If you're applying an egg-based medium to rapidly drying wet plaster, then the answer is obvious: by the end of a day, the *intonaco* has begun to form a crust and won't take any more colour. But Gall works in oils on canvas. The whole point of the invention of oil paints — the miracle of the great Eyckian revolution! — was that it freed artists from the constraints of time. And yet, just as Gall had turned his back first on drawing and then on London, so he now appears to spurn the benefits of post-Renaissance technology.

It's the kind of thing to make you feel a faint twinge of despair and so, oddly, does Neil Gall. Gall has that laconic wiriness that suggest periods of intense energy punctuated by moments of laughing at himself. When I ask him why he works in the apparently perverse way he does, he grimaces, saws the air with his hands and eventually says, "It's a self-imposed reigning-in, a kind of self-control. The idea of a painter who can come into his studio, do as many hours as he feels like doing that day and then go off home is absolute anathema to me." He thinks a bit more and says, "I don't know how they do it. Living with endless possibilities on a daily basis would just be impossible for me." Then he gets up, stalks across the studio, puts his blue cardboard moulding on a plinth and says, "One day, I may be able to do *this*, to make *this* kind of art, be this kind of artist. But at the moment, it's not what my work is about. It's about, you know, *labour*."

(As an aside, I should say that Gall describes himself as inarticulate. Discussions of his own work obviously hurt: he is prone to describe his career — the changes in his iconography and style — as the search for a language with which to talk about his art. For what it's worth, it strikes me that Gall's work, like Gall, is inordinately articulate, inventing its own syntax and grammar and using them to write its own history.)

It must be said that "labour" sounds like something in the way of Scottish understatement. "Torture" seems a more appropriate word to describe Gall's practice, or maybe "masochism". As we spoke, I had a momentary image of Neil Gall as a kind of painterly St Lawrence, pointing mournfully at a grid as the symbol of his martyrdom. Like St Lawrence's, Gall's roasting on a griddle is at least partly self-elected. There was a much easier way out for both men, and neither chose to take it.

Actually, on one level it seemed that Gall might have freed himself from the grid in a series of pictures he has been working on since 2004. Paintings like *Bather* and *Descent* draw heavily on the apparently sado-erotic work of Hans Bellmer, made in Berlin in the 1930s and then, after the artist's classification as decadent by Nazi critics, in Paris. Bellmer's most famous (and most vexing) works were his *poupées* or dolls, and Gall has been modelling Bellmer-ish dolls of his own in his studio, wrapping ping-pong balls in electrical tape and then painting the results.

Although his working method has remained the same, Gall's Bellmer paintings look like a bid for freedom from the grid. Spheres are emphatically not square and, being three-dimensional, are not easily prone to mapping. If Gall's earlier work had been consciously cartographic — that is to say, concerned with the problems of gridding-up the world — *Bather* and *Descent* seem to glory in their roundness, their in-the-roundness.

And yet their freedom is of a curious kind. As Gall's wrapped-ball paintings have progressed, so they have seemed to buy more and more heavily into the aesthetic of sado-masochism. One, *Tyburn*, looks like a profile portrait bust of Queen Victoria in bondage gear, or maybe unspecified male genitalia encased in black leather. Another Bellmer work, the smaller of two pictures called *Performance*, reminds you of the kind of S&M apparatus seen in the windows of Dutch sex shops.

At this point, any idea that these canvases might represent a bid for freedom on Gall's part seems to evaporate. By contrast, the work appears to rejoice in constraint, in its own state of being bound and gagged, tied up. Gall's description of his working method as "a self-imposed reigning-in" suddenly takes on a whole new meaning. As with his grid pictures, so these Bellmer works are both the representation of models and the model of a kind of representation. They are tortured pictures of a tortuous process, fetish-objects in the cult of Gall's own practice.

138

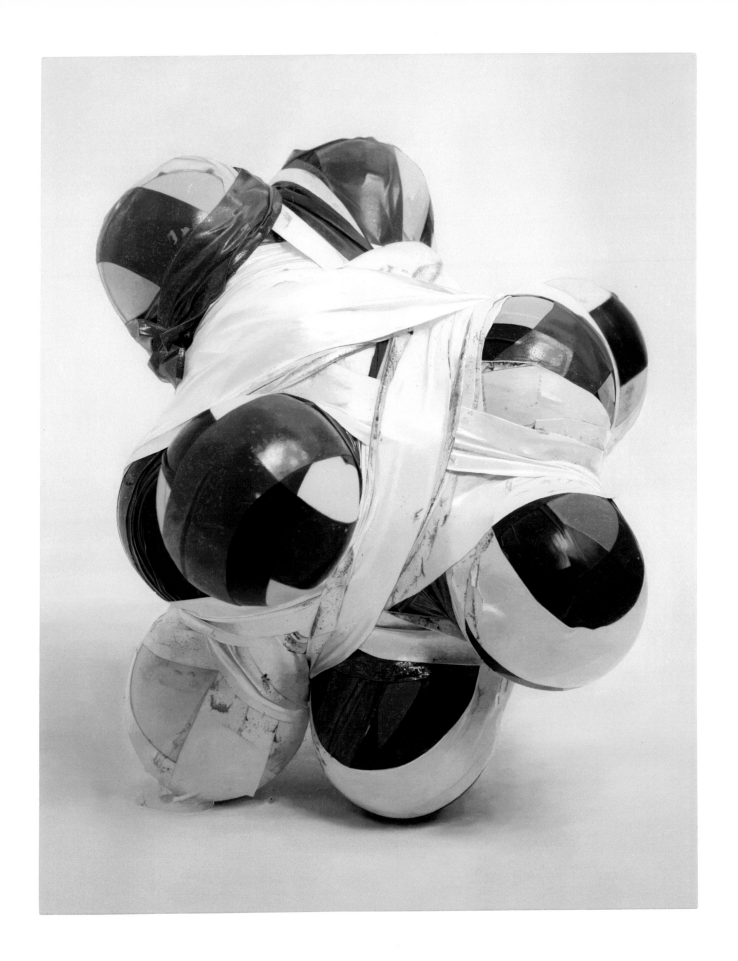

charles darwent **ON THE GRID**

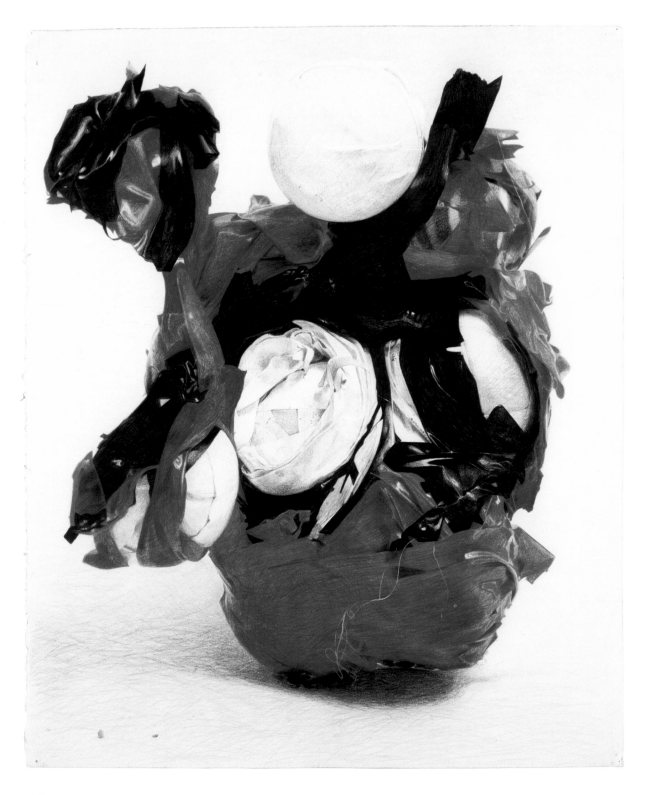

Watcher
2005, coloured pencil on paper, 78 x 65 cm

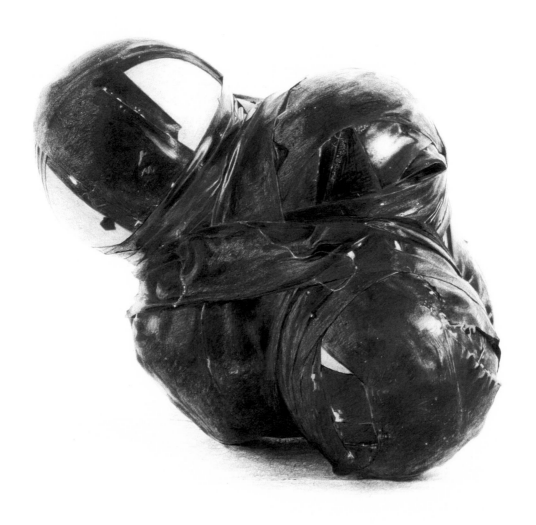

Black performer
2005, coloured pencil on paper, 69 x 66 cm

charlesdarwent ON THE GRID

Descent (landscape)
2005, oil on linen, 61 x 76 cm

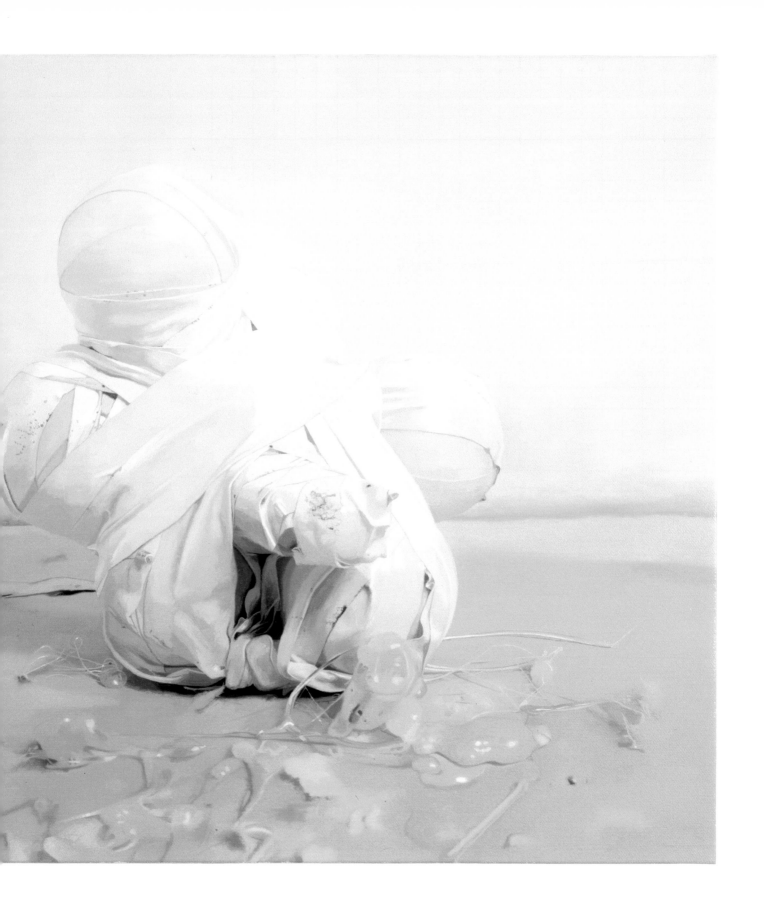

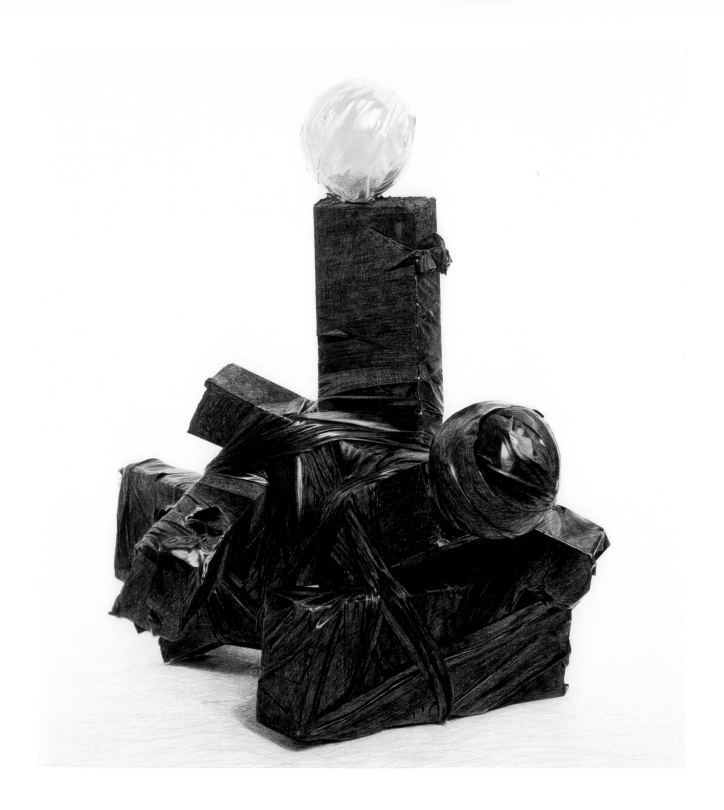

Sculpture
2005, coloured pencil on paper, 75 x 71 cm

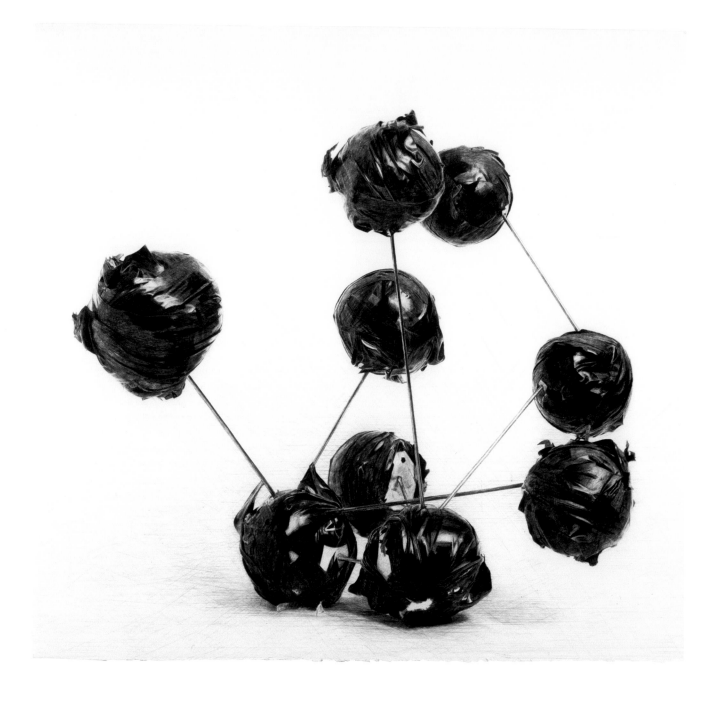

Pod
2005, coloured pencil on paper, 85 x 89.2 cm

charlesdarwent ON THE GRID

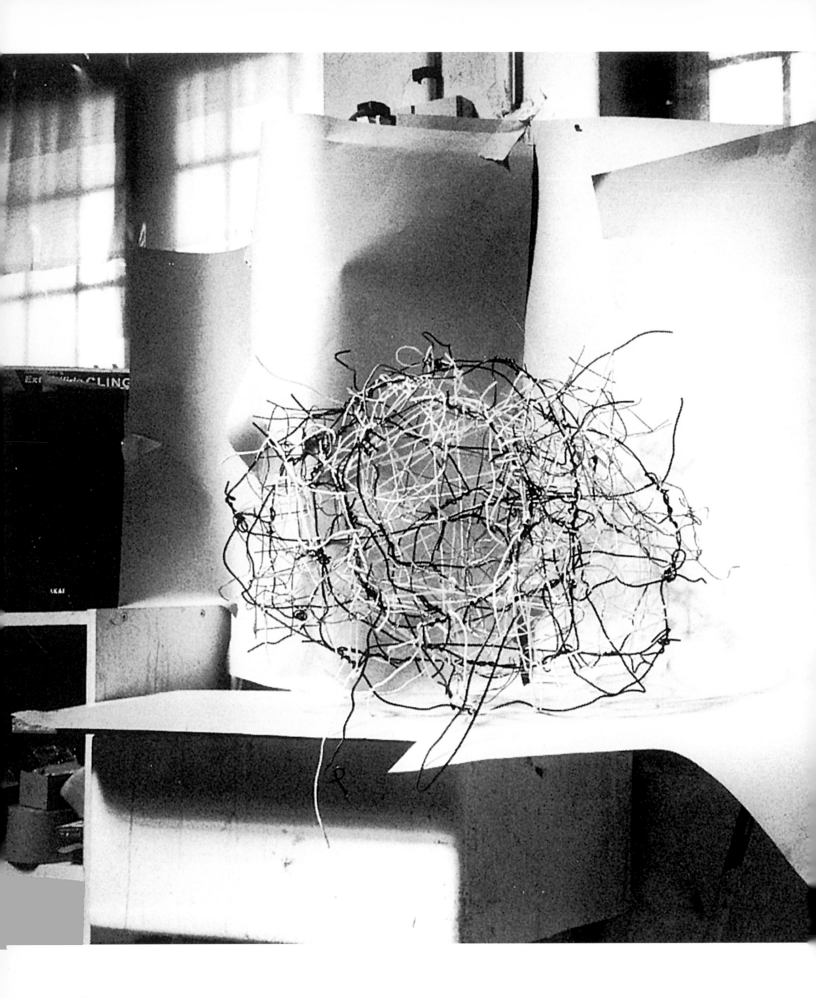

charles darwent **ON THE GRID**

Wire sculpture used for
Model Painting: Babble
(illustrated page 13),
2000, studio

It struck me recently that the term 'drawing' has expanded in the past ten years to take in just about every conceivable form of artistic practice, including, when occasion demands, video and sound installation. My feeling with Gall is that he has spent this same time quietly pushing away at the edges of the grid — a fate to which grids may arguably be prone. One of the core ambiguities of his work has always struck me as being whether structures are good things or bad things, whether they support or imprison. Fairly often, Gall's look like bars or gates. And the same doubts have clung to the idea of *being* structured, of working in a structured way.

As I've mentioned, Neil Gall's paintings are profoundly aware of their own history. His grids mark the diurnal story of their making in the studio — all those *giornati* — as well as the much longer story of Modernism and Modern art. But Gall's own grids, made of wire or gaffer tape or roller coasters, have not stood still either.

When I first wrote about Gall, he had embarked on a new series of pictures — the first to use hand-made models in the studio and thus known, appositely, as the *Model Paintings*. I recall being mildly taken aback when he described the process of making these. First, Gall built his models out of bent wire, plastic and string; then he took six sets of nine photographs of each Constructivist-looking amalgam and arranged them on the same three-by-three grid as *Loop* and *Mousetrap*. He then picked photographs from each of the six sets of photographs in painting his final picture, ending up with a mosaic of different lighting conditions and processing tints.

Reproducing these as truly as they could, the resultant canvases were full of disjunctions: Gall was particularly cheered when an artist friend described them as "Brice Marden with a stutter". Thanks to his insistence on working in *giornati*, this process took an extraordinarily long time. The four corner sections were painted first, then left to dry for seven weeks. The central panel was then painted and left for another seven weeks; finally, the four remaining sections were done and likewise left to dry.

Model Painting: Choker
2000–2001, oil on canvas, 145 x 183 cm

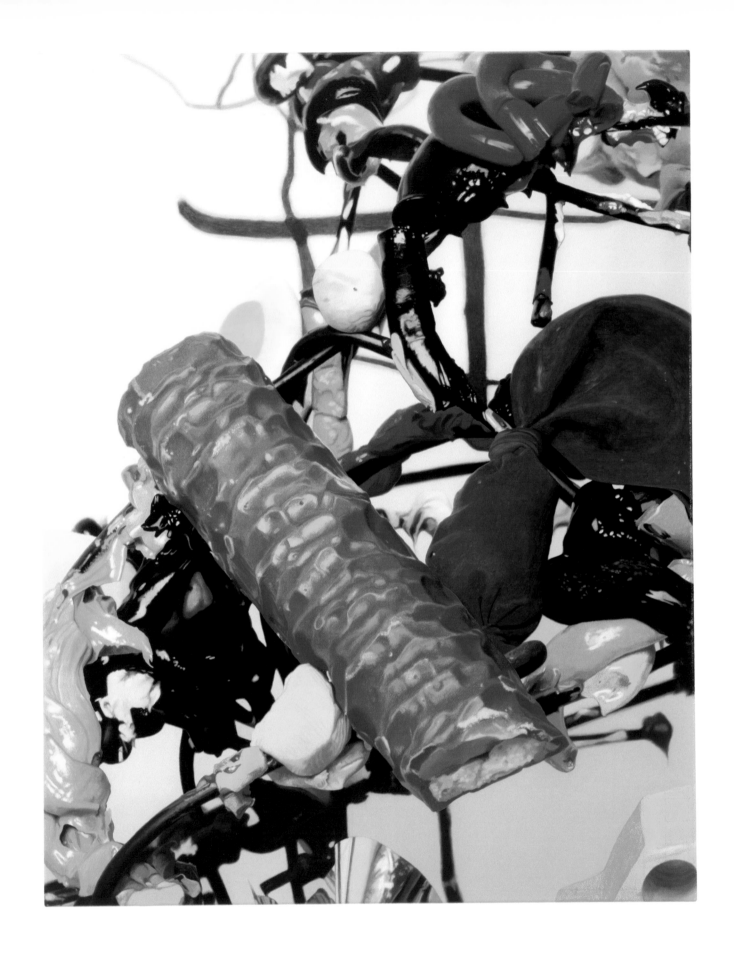

Any other artist might have used the experience gained from all this to speed up his output. By contrast, Gall found an even more painstaking way of working, and slowed down. By 2003, paintings like *Cast* were taking a Stakhanovite five months to finish. Even by his own exacting standards, Gall describes the larger of his two *Performance* paintings as "incredibly laborious". "I worked 20 hours non-stop to get the background done in a single day", he says. "I got to bed at five am and was back here at nine to finish off *this*." He points to a passage depicting a painted tinsel ball.

Two things strike me as particularly extraordinary about all of this. The first is the layering of Gall's practice: seeking out found objects, turning those objects into models, photographing them, and then painting the result. The second oddity of Gall's method is that all this labour is expended on rubbish. These aren't found objects in the satirical mode of Duchamp, the political moralising of Arte Povera or even the tidewater romanticism of early Tony Cragg. The subjects of works such as *Cast* and *The sooner you get away from here the better* are cheap, gimcrack, kitsch, tawdry: scrunchies, tinsel balls, half-eaten chocolate bars, hair grips, My Little Ponies. Gall's own term for the aesthetic they create is "a pound-shop sensibility".

In terms of his peers, it is as though Wayne Thiebaud had begun to work in the style of Thomas Demand. Like Gall in his more additive photo-realist moments, Thiebaud paints pictures of worrying sugariness — literally, since the subject of his best-known works is confectionery. By contrast, Demand parallels Gall in making meticulous models, photographing them and then destroying the originals. As with Gall's canvases, the question Demand asks is where the art lies: in the model, in the two-dimensional recording he makes of it or in the whole performance of the making?

To my mind, Demand is also like Gall in being a moralist. In choosing insistently dull subjects to model and photograph — suburban houses, kitchenettes — he invokes something of the banality of evil: his kitchen turns out to have been the one in Saddam Hussein's Tikrit bolt-hole, his suburban house to have been the site of a recent child murder. The tawdriness of the objects in *The sooner you get away from here the better* and *The precipice* also seems to hint at a story beyond their bright colours and sugary surfaces, although that story seems to have more to do with the evil of banality than the other way around.

151

WAYNE THIEBAUD
Three machines
1963, oil on canvas, 76.2 x 92.7 cm

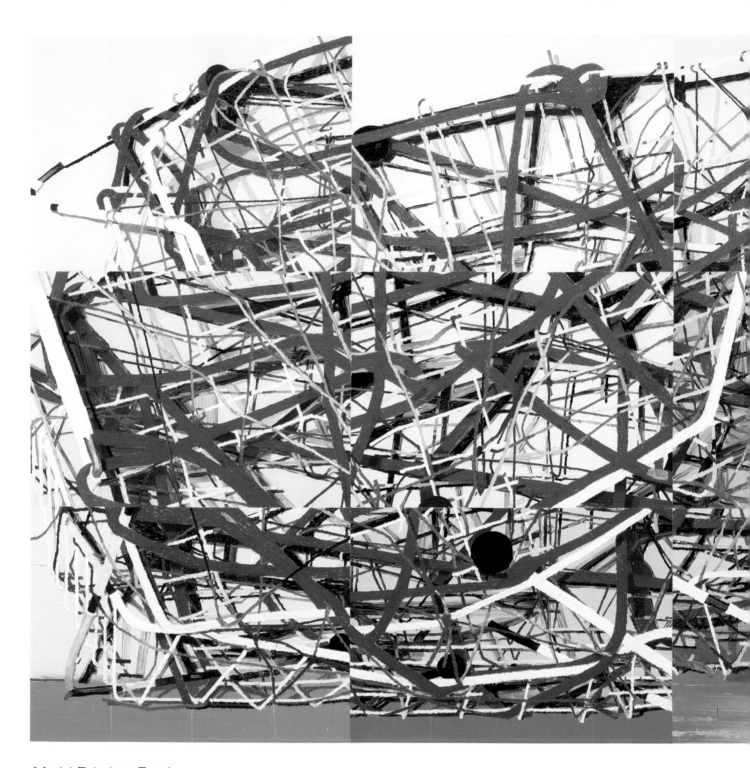

Model Painting: Crash
2000–2001, oil on canvas, 153 x 213.5 cm

As I've mentionned, Gall's grids are both historical and autobiographical. At various times in his career, they appear as cages or traps. Sometimes, you sense that he feels haunted by them as the graph on which he plots his own progress, or lack of it. Through his successes and occasional failures, the grids have always been there as a way of measuring what has gone before and what is to come. "One of the worst things", he says, looking at *Cast,* "is the way that one body of work can negate a previous one as having been no good. I'm always worried that I'll look back in two years and think, "They're all shit." When I first showed this to Selina [Gall's wife], she said, "Oh god, not that thing again — not *that* bloody basket."

The basket in question was made of wire and looked as though it had been stolen from a supermarket and then junked. It put in an appearance in Gall's paintings for upwards of four years, showing up first in 2001 in works like *Crash*, taking a starring role in Cast and only leaving the stage after Gall went into his Bellmer phase in 2004. My last sighting of it was in the larger of the two *Performance* paintings, where it seemed to be in the process of being pushed off the canvas by a determined Bellmer ball-doll.

There are all kinds of ways of reading this curious object. In art historical terms, it is our old friend the grid. Gall's take on this seems to have followed the history of Modernism from Tatlin's *Tower* via Brice Marden to something that looks rather more like James Rosenquist. (Or, maybe, like Gerhard Richter, which may suggest that Gall now feels he has got where he wanted to go by a route of his own devising.)

3_The first paintings produced in photo-realist style are illustrated on the two following pages.

Stylistically, the evolution of Gall's baskets has led him from the broadly abstract impasto of *Mousetrap* and *Loop* to the representation-that-looks-like-abstraction of model paintings such as *After Right After* and *Working Days*, both from 2001, and from there to the flat-surfaced photorealism of most of the pictures he has produced since 2002.[3] At the same time, the wire grids mark a move in Gall's practice from the hand-made to the readymade; from constructing a model that looks like a wire basket to finding a wire basket. (The cardboard subjects of his new packaging works involve even less in the way of intervention.) In plain, formal terms, the bashed-about nature of these baskets also allowed the rigid structure of Gall's early work to become progressively more bent out of shape. There's a moment in his career — beginning roughly in 2005, with works like *Materials for reasoning* and *Hidden by the calamities* — when the wonky grid seems suddenly to give birth to spheres, stuck on the end of its filaments like olives in a martini. *Performance*'s Bellmer balls don't so much challenge Gall's squared-up wire matrix as acknowledge it as an ancestor. His ballsy sex-toys may not look like grids, but they are born from grids all the same. And the grid — gridding up, gridding down — has been both the subject and the means of Gall's art-making. *Mousetrap* was the scaled-down image of a vast object. Whatever he chooses to call his blue pressed cardboard piece, it will be the monumentally scaled-up image of a small one.

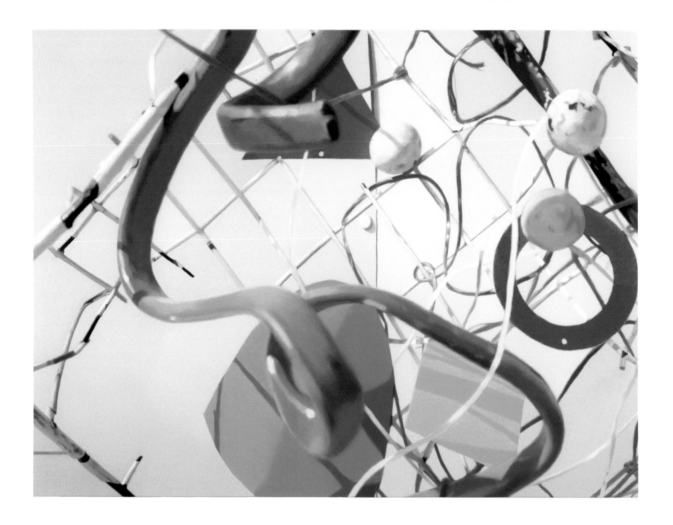

Orbit (1)
2002, oil on canvas, 106 x 140 cm

None of this, though, quite answers the central question about his work: why paint trash? Looking again at *Cast* and *The sooner you get away from here the better*, two thoughts strike me. The first is that they are unexpectedly political pictures, at least in the broad sense of the word. I don't mean that Gall's hair grips and half-eaten Twix bars should be read as a broadside against the mores of a consumerist society, but they do raise the whole issue of consumption.

More, they raise the question of their own consumability, their role as consumables. These are works made with evident skill — indeed, works that wear their skill on their sleeve. And yet that skill, like the litter it is used to portray, seems to be thrown away, squandered on depicting objects that are emphatically unworthy of depiction. There is a bewildering prodigality to Gall as a prodigy. Here is a painter who knows how to draw, who spends five months getting a picture right, who went back home to reclaim his artistic roots. And what does he do with that reclamation? He paints little plastic ponies.

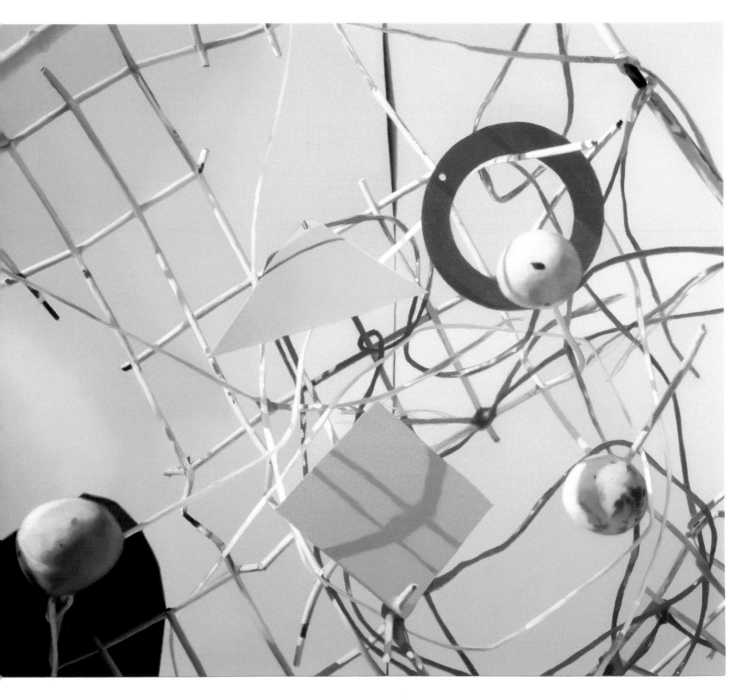

Orbit (2)
2002, oil on canvas, 106 x 140 cm

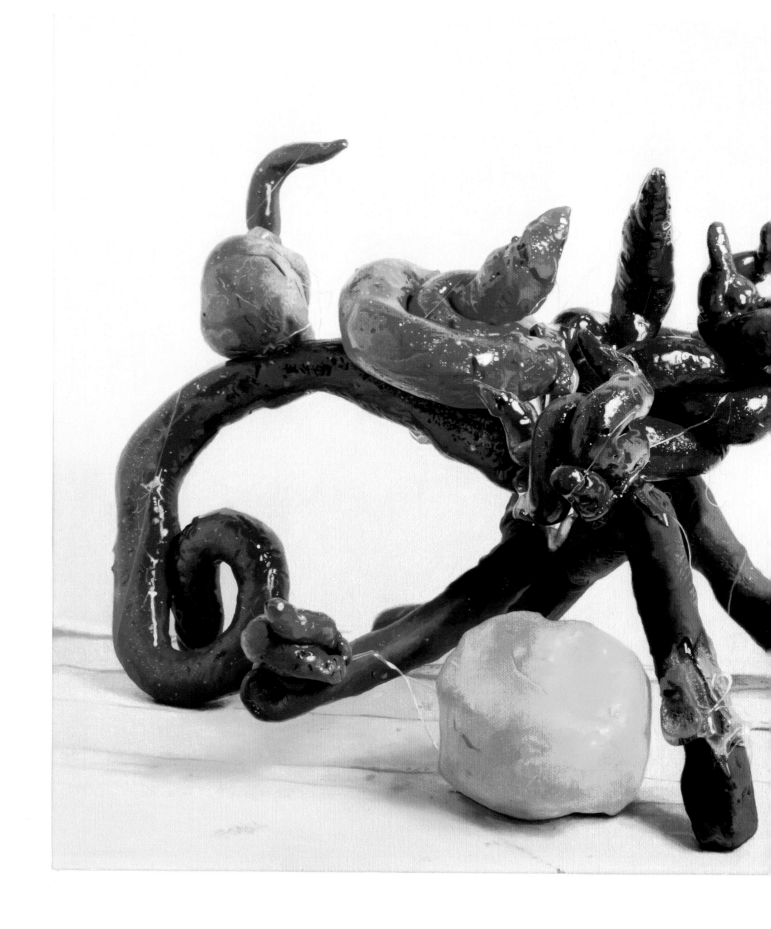

And yet I'd say that this is exactly where Gall's extraordinariness lies. In acknowledging consumerism, works like *Cast* also raise doubts about their own place as consumables. By making what you might call "good painting", Gall has found a way out of the *impasse* of Postmodernism. For the past 50 years, it has only been possible to paint well by painting ironically. Yet Gall's work doesn't so much ironise as interrogate itself. It brings up all the big, old questions about art, including what it is, what it's worth and why. Of all the various knife-edges on which they sit — representation and abstraction, modernity and tradition, objectivism and subjectivism — this is the one that gives his paintings their voice. It's an even-handedness that seems constantly to walk a line between hope and despair.

The second thing that strikes me about works like *Cast* and *The sooner you get away from here the better* is that they are open to obvious Freudian interpretation. Oddly, it isn't the perviness of Gall's Bellmer paintings that suggests this reading most strongly. It is the complexity of these earlier, more-is-more pieces that begs the question of how they hang together as a narrative; why all their constituent parts are there, and what kind of syntax holds them together.

Often, that syntax seems to be autobiographical. Standing in front of one of his works — *Playtime* — Gall describes it as "pooey painting: primary colours, squishy things". By way of explanation, he goes on, "We had a baby right in the middle of my making this." Talking about the model for another work, *Materials for reasoning*, Gall remarks that his infant son would come in and reclaim his borrowed toys from it when his father wasn't looking. "Louis would undo my constructions for me, impose a kind of mimimalism" as Gall puts it. "And having kids meant having the detritus from kids' parties — burst balloons and that kind of thing." These are clearly visible in *Cast*, alongside the toy cars and Twixes.

This suggests the opposite of that hermetic working method followed by artists in popular fiction. It also implies that Gall sees his life and art as bound up in each other in a way that structuralist theorists have long turned up their noses at. Gall is very much his own *auteur*, although this is not the same thing as saying that he is unduly knowing about himself. Looking at *Cast*, it suddenly strikes him that the picture's hair scrunchy may not just be there to help conjure up his pound-shop sensibility. "What does a scrunchy do?" Gall asks, of himself as much as to anyone else. "It holds things in place, like a grid or tape. Looked at another way, it's a vagina."

159

Detritus under artist's sofa,
2006, artist's photograph

Somewhere in all of this, you sense a paradox at work. I suppose every artist creates his own set of rules; in Gall's case, though, those rules seem to be almost perversely hard to follow. It is as though he fends off the threat of endless possibility by making his own artistic life impossible. And yet that means his work is constantly struggling against a self-imposed entrapment. I don't want to labour the similarity between grids and prison bars or instruments of torture; but that similarity is clearly there in Gall's work.

Occasionally, this cycle of entrapment and escape has steered Neil Gall into dead ends. To my mind, his more Koons-ish fantasy pieces — works like *The precipice* and *The Upperworld*, with their Barbie Doll sensibility and little toy horses — overplayed their hand. As a recent father, it may well be that Gall was struck by the horrors of rampant consumerism and the cynical playing of toy companies on the infantile taste for glitter. His better work has kept its cards close to its chest, so that it seems just as likely that Gall is actually seduced by the gaudy colours of *Playtime* as he is critical of them. Whatever else it is, his foraging and model-making is playful, experimental in a child-like sense. *The precipice* feels too satirical, too grown-up.

Given this, Gall's explanation for the piece is interesting. "It became a big thing in my mind as a way of negating all of this" — he points at *Crash* — "a way of finding something I could talk about. At the moment, I don't need little 'planes or little horses, but I *really* needed them then, their weird romanticism. That series of pictures may not have led anywhere, but they were certainly much easier to talk about. At the very least, I could say 'horse' or 'plane'."

162

At the moment, I don't need little 'planes or little horses, but I *really* needed them then, their weird romanticism.

Newspaper clipping from artist's workbook

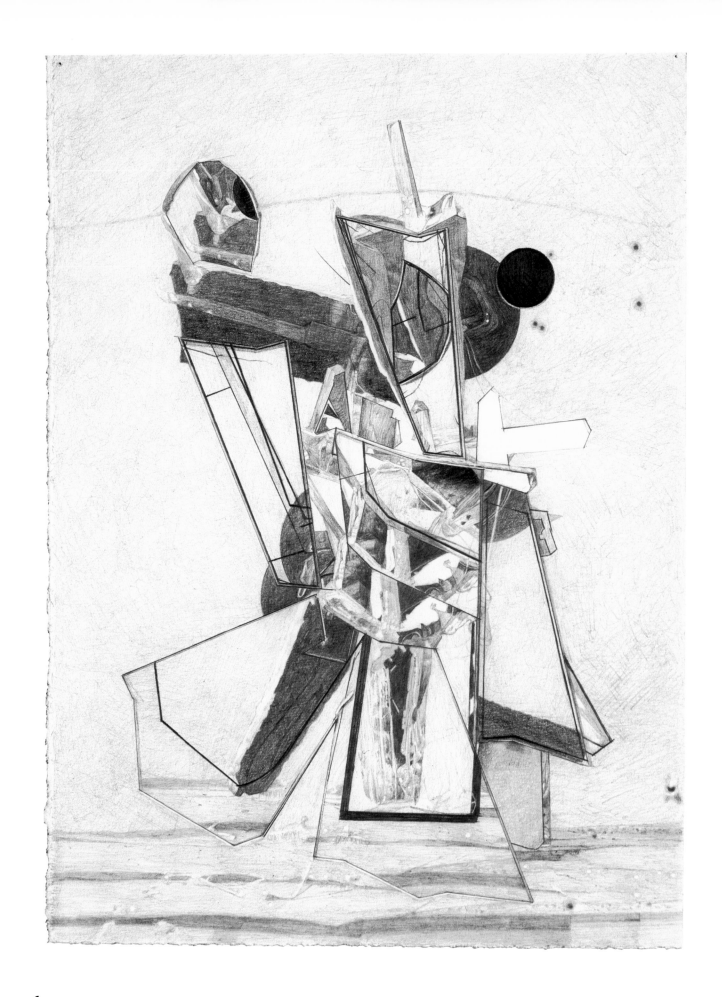

That may be their problem, in fact. For me, Gall's story begins with a return to childhood, a trip back to the family home. As I've described, the works that came out of that trip took infantilism as their subject: Mousetrap is a kid's game, roller coasters are for children. At the same time, Gall's Aberdeen pictures also looked back, stylistically, to the infancy of Modernism. And, in a sense, it strikes me that his career has consisted of a series of startings-over, of searches for a new child-likeness, a rediscovered innocence.

Whatever else his scalings-up and scalings-down have done, they have made the viewer (and, presumably, Gall himself) see himself as bigger or smaller. As with the drink-me bottle in *Alice in Wonderland*, we are constantly being made to shrink or grow; which is another way of saying that we are made adult or child-like. At his best, Gall never allows us the comfort of knowing where we stand on the matrix of childhood and adulthood. The trouble with *The precipice* and its kin is precisely that they let us see where we are. The works are post-linguistic in that they have words to describe themselves, that they know the language of what they're about.

165

As with the drink-me bottle in *Alice in Wonderland*, we are constantly being made to shrink or grow.

Newspaper clipping from artist's workbook

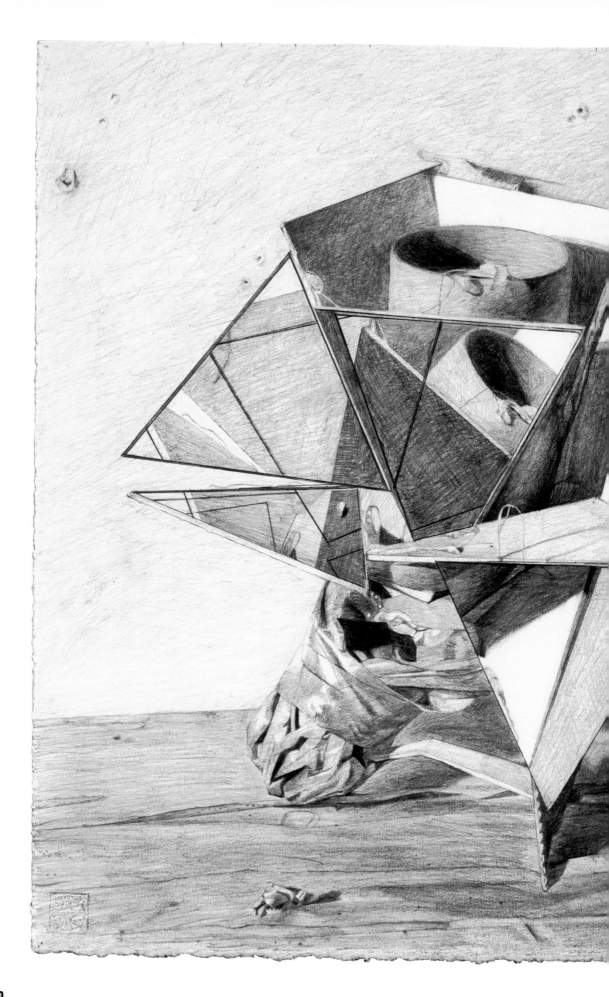

La Femme collage drawing
2006, graphite on paper, 31.7 x 29 cm

Which makes the question of where Gall goes next a difficult one to answer. When I saw him shortly before starting this essay, his work had just moved off in two ways that seemed diametrically opposed to each other. On the one hand, he had begun to use largely unmediated found objects in his pictures — bits of pressed cardboard packaging drawn to look like bits of pressed cardboard packaging, whose transformation lay only in their context. On the other, he had started doing meticulous, finished drawings as opposed to preparatory sketches for paintings. He joked about going forward by making a move into readymade sculpture — putting found objects directly on to the plinth — but at the same time he had begun to make laborious graphite representations of works he'd already made in collage. Even as Gall was daydreaming about a less intensive, less demanding way of making art, so he was adding another layer of intensity and demand to his practice.

And yet this paradox has recurred again and again in his history. Whenever Gall has looked to the future, so he has also turned to the past. Making a drawing of a collage seems the wrong way around, as though the film of his life was being played backwards. And yet reclaiming drawing — reclaiming the *right* to draw — is precisely where his post-Richter life began. To earn the ability to put a piece of cardboard packaging on a plinth and call it art, you have to be able to do the opposite. To paint like Gerhard Richter, you have to be able to paint unlike Gerhard Richter. It's a stern position to take, and a difficult one. And yet this moral stance — I think moral is the word — is implicit in all Gall's work, and gives it its power.

list of works //

NEIL GALL IS REPRESENTED BY HALES GALLERY, LONDON.
Photography Gareth Winters.
Except drawings (illustrated pp. 36–37, 97, 134, 140–141, 144–145, 164, 168), photography John Jones, London.
Workbook, photography Michael Franke.

acknowledgements//

NEIL GALL WISHES TO THANK Selina Mason, Duncan McCorquodale, Rachel Pfleger, Simon Groom, Johanna Malt, Charles Darwent, Hales Gallery, Paul Hedge, Paul Maslin, Ella Whitmarsh, Sandra Mahon, Safiya Waley, Gareth Winters, Matt and Kate Jones, Will Cotton, Thomas Demand, Mike Kelley, Ruth Lough, Ian McKeever, Alexander Fraser, Michael Franke, James Rielly, Bob Mathews, Simon English, Mary Boone Gallery, Victoria Miro Gallery, Frank and Louisa Gall, Louis and Cecily Gall, Margaret Mason, Rachel Lynn.

173

© 2007 **BLACK DOG PUBLISHING** limited, the artists and authors
All rights reserved

Written by Simon Groom, Johanna Malt and Charles Darwent

Designed by Rachel Pfleger @ bdp

Black Dog Publishing Limited
Unit 4.4 Tea Building
56 Shoreditch High Street
London
E1 6JJ

T. +44 (0)20 7613 1922
F. +44 (0)20 7613 1944
E. info@blackdogonline.com

British Library Cataloguing-in-Publication Data.
A CIP record for this book is available from the British Library.

ISBN10. 1 904772 73 0
ISBN13. 978 1 904772 73 6

Printed in Turkey by Ofset Yapımevi

BLACK DOG PUBLISHING is an environmentally responsible company.
Shelf life is printed on Fedrigoni Symbol Freelife Satin, an environmentally-
friendly ECF (Elemental Chlorine Free) woodfree paper with a high content of
selected preconsumer recycled material.

architecture art design
fashion history photography
theory and things

www.blackdogonline.com